D1165343

Meet Edvard Munch

Published by the support
from the Royal Norwegian Ministry of Foreign Affairs

NORWEGIAN MINISTRY
OF FOREIGN AFFAIRS

Published by support from Fritt Ord

Authors
Hilde Dybvik, Lasse Jacobsen,
Ellen J. Lerberg, Lill Heidi Opsahl,
Sivert Thue and Hilde Ødegaard

Editors
Hilde Dybvik, Lill Heidi Opsahl
and Ellen J. Lerberg

Picture research
Julie Knoff Smith

Translation
Stig Oppedal

Photographs of works of art
and documentary material
in the Munch-museet's collection:
© Munch-museet (Svein
Andersen, Halvor Bjørngård,
Sidsel de Jong, Jaro Hollan)

Cover
Edvard Munch, *The Girls
on the Bridge*, 1927. Detail.
Oil on canvas.
Munch-museet, Oslo

Back Cover
Edvard Munch, *Airedale Terrier*,
1919–20.
Oil on canvas.
Munch-museet, Oslo

Page 4
Edvard Munch, *Self-Portrait*
(1886). Detail.
Oil on canvas.
Nasjonalmuseet for kunst, arkitektur
og design, Oslo

Design
Marcello Francone

Editorial Coordination
Emma Cavazzini

Editing
Andrew Ellis

Layout
Serena Parini

First published in Italy in 2013 by
Skira Editore S.p.A.
Palazzo Casati Stampa
via Torino 61
20123 Milano
Italy

www.skira.net

© Nasjonalmuseet for kunst,
arkitektur og design, Oslo 2013
© Munch-museet, Oslo 2013
© 2013 Skira editore
© André Derain / BONO, Oslo 2013
© Karl Schmidt-Rottluff / BONO,
Oslo 2013
All Edvard Munch's works
of art: © Munch-museet /
Munch-Ellingsen Gruppen / BONO,
Oslo 2013
© The Andy Warhol Foundation
for the Visual Arts Inc./ BONO,
Oslo 2013

Printed and bound in Italy.
First edition

ISBN: Skira editore
978-88-572-1947-9
ISBN: Munch-museet
978-82-90128-81-9
ISBN: Nasjonalmuseet
978-82-8154-077-4

Distributed by Thames and Hudson
Ltd., 181A High Holborn, London
WC1V 7QX, United Kingdom.

Meet
Edvard Munch

SKIRA NASJONALMUSEET MUNCH museet

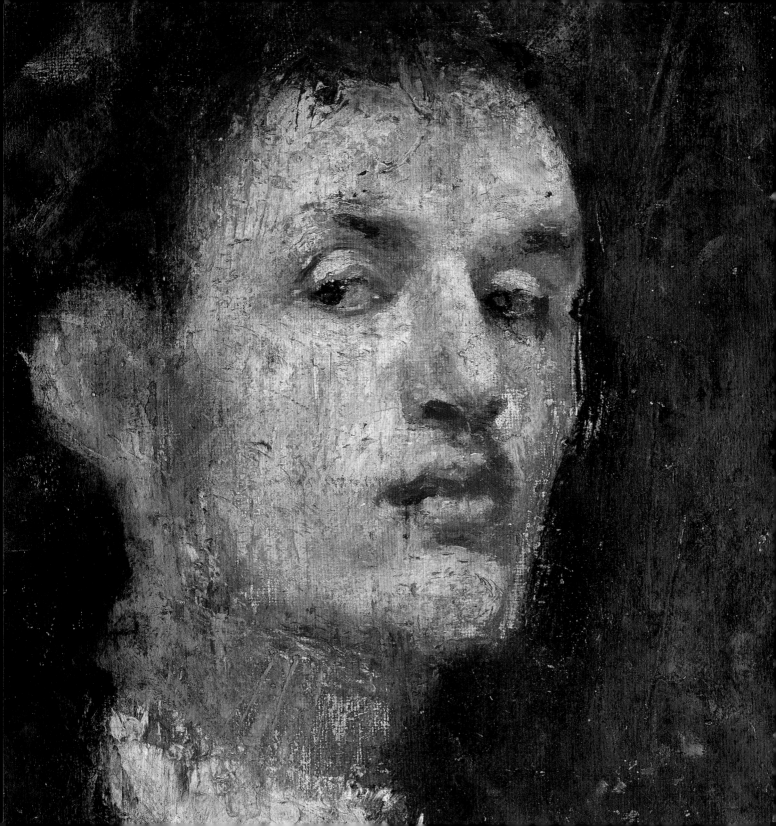

Contents

Edvard Munch (pronounced "Munk") is born 12 December on Engelaug Farm in Løten in the Norwegian county of Hedmark, to Dr Christian Munch and Laura Cathrine Bjølstad. The family moves to Kristiania (modern-day Oslo) the following year.

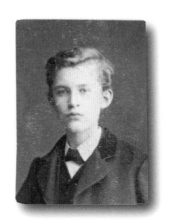

His elder sister Sofie dies.

1863 1868 1877 1880

His mother Laura dies. His Aunt Karen, Laura's sister, comes to take care of the family.

Attends the Royal School of Drawing in Kristiania.

Rents a studio at Stortings Plass in central Kristiania along with several other artists, and receives instruction from the painter Christian Krohg.

Becomes friends with Hans Jæger and the so-called Kristiania Bohemians.

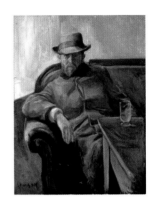

1882　　**1885**　　**1886**　　**1889**

Exhibits his paintings at the Antwerp World's Fair. Travels often between 1885 and 1909, with lengthy stays in Paris, Nice, and Berlin.

Holds his first solo exhibition in Kristiania. Travels to Paris, where he receives instruction at Léon Bonnat's studio. His father dies.

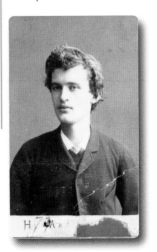

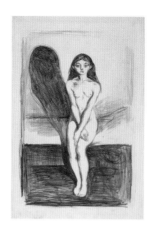

Paints *Despair*, which he would later enhance in *The Scream*. Exhibits paintings at the Association of Berlin Artists, but public outrage forces the exhibition to close after only a few days.

His first graphical works are printed in Berlin.

1892　　1893　　1894　　1896

Moves to Berlin. *The Frieze of Life* begins to take shape. Paints the first version of *The Scream*.

Works with different printing techniques in Paris. Makes his first woodcuts and colour litographs.

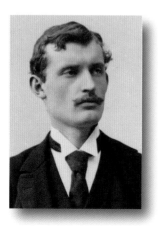

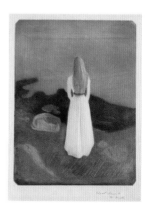

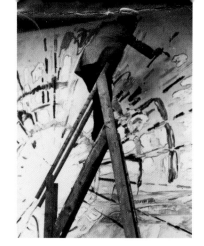

Exhibits a series of paintings later known as *The Frieze of Life* in Berlin.

Moves back to Norway. Begins making draft versions of his large-scale paintings for the University Aula in Kristiania.

1902 1906 1909 1912

Designs decorations for Ibsen's plays *Ghosts* and *Hedda Gabler* for the Max Reinhardt Theatre in Berlin. Creates a frieze for the theatre in 1907.

Major exhibition in Cologne, Germany, features works by the artists Cézanne, Gauguin, van Gogh, Munch, and Picasso.

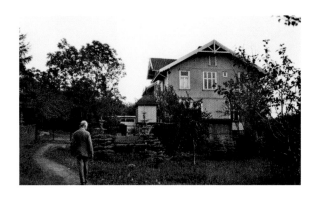

Munch buys the Ekely estate, which at the time was outside the city limits of Kristiania.

Designs decorations for Oslo City Hall.

1916 **1922** **1928** **1929**

Makes paintings for the workers' lunchroom at the Freia Chocolate Factory in Kristiania.

Builds a new winter studio at Ekely.

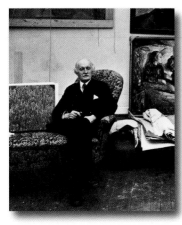

Munch dies on
23 January at his
home in Ekely. He had
bequeathed all his
remaining works to
the City of Oslo.

1944 **1963**

The Munch-museet
opens in Oslo.

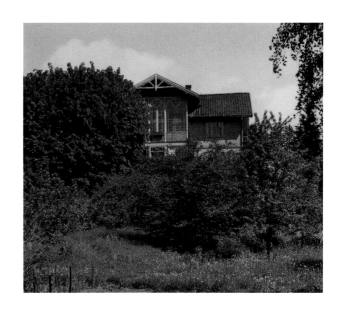

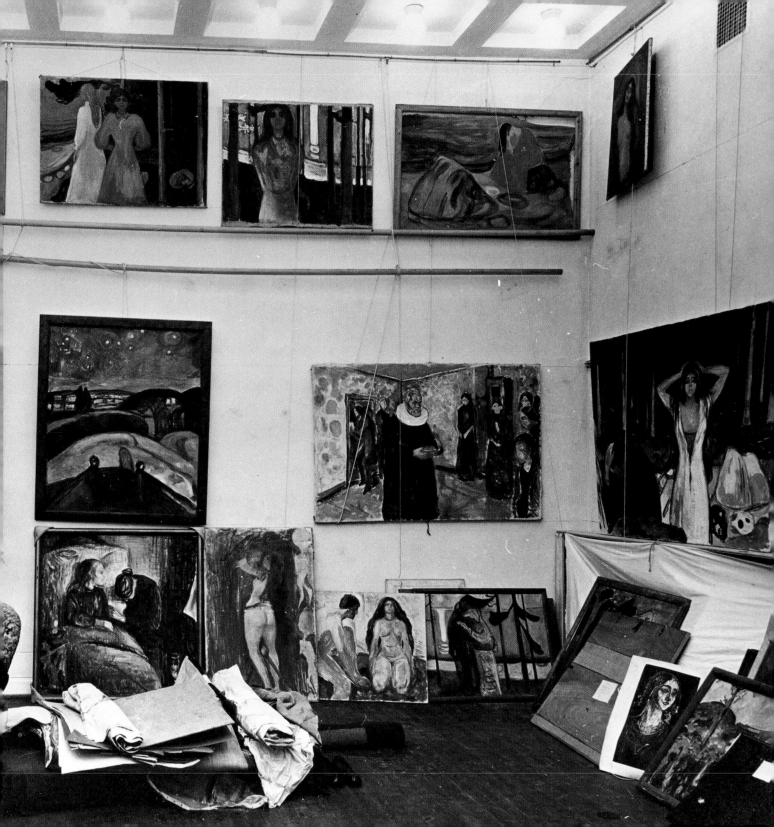

Hilde Dybvik

What We Know and What We Don't Know

Every now and then Edvard Munch's paintings are transported around the world. This takes plenty of time and effort, because if a museum in another country wants to borrow a Munch painting from the Munch-museet or the Nasjonalmuseet for an exhibition, many protective measures must be taken. Security and secrecy are at top level: the cargo is extremely valuable, and not just anyone should know about it. When the paintings arrive, they are carefully examined: Are they in just as good a condition after their journey as they were before? And when they return to the museum, they are re-examined: How have the paintings been treated at the other museum? And how have they fared during transportation?

On 9 December 1901 the steamer *Kong Alf* was on its way from Hamburg when there was a sudden explosion on board, and one of Munch's paintings was destroyed. We know that the painting was titled *Summer Night. Two People*, and that it was painted in either 1892 or 1893. But the painting itself is lost forever. This makes us aware of everything we *don't* know, and that we will in fact

◀ The studio at Ekely, 1938, detail.
Photo: Væring. Munch-museet Archives, Oslo

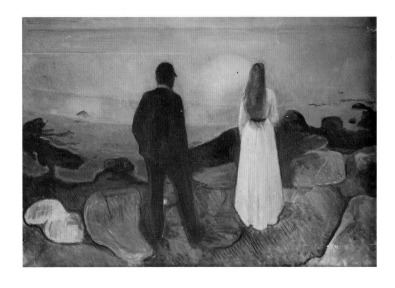

never know: what Munch thought, what he sounded like when he talked – we simply cannot know. There is not a single recording of Munch's voice.

But what we *can* say something about is all his surviving works of art and texts. And the amount is staggering: in the Munch-museet alone there are more than 1,100 paintings, 7,500 drawings and watercolours, and around 250 sketchbooks and notebooks. He also made over 17,000 prints. In addition, around 15,000 pages of his writings survive.

Just imagine how much *could* have vanished!

The art and writings that Edvard Munch left behind contain plenty of information about the artist himself and his work, and provide us with some answers about who he was and how he worked. It is primarily these sources that the authors have used to write this book.

But why did Munch keep all of these writings and works of art? What motivated him? Was he obsessed? In many respects it might seem so. He is simply *unable* to stop, unable to get the images out of his head. He *has to* work, it is like an obsession, an addiction. Again and again he wrestles with the same

themes. There is so much he wants to pass on! He works frantically, paints, re-paints, makes changes, begins over again, creates new variants, until he finds the most perfect form – that is, if he ever does find the perfect form. For what is perfect art?

There are many different answers to that question. What is certain, however, is that Edvard Munch's art is known – and admired! – the whole world over, and that his art affects us strongly, even though he died decades ago, and even though the world has changed dramatically since his lifetime.

Come on a journey back in time to when Oslo was known as Kristiania, a time when cars were rare and computers and cell phones were a thing of the future. It was during that time that Munch worked as an artist: he organised exhibitions across all of Europe, travelled and lived in a variety of places, and learned the languages he needed to know. Edvard Munch was both a major artist and a shrewd business-man – that is something we definitely do know.

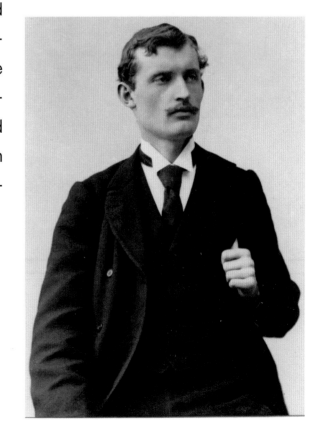

Edvard Munch, 1892.
Photographer unknown.
Munch-museet Archives, Oslo

Edvard Munch, 16 years of age (1879).
Admission card for participants
at the *Industry and Art Exhibition*
in Kristiania, 1883. Photo: J. Lindegaard.
Munch-museet Archives, Oslo

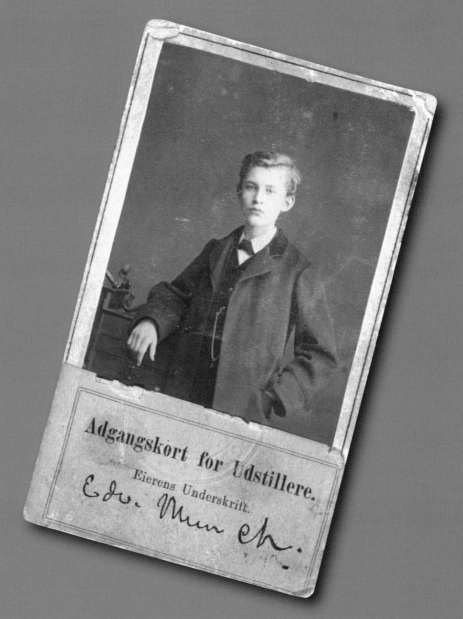

Lill Heidi Opsahl

Impulses

Munch was inspired by and received impulses from both Norwegian and foreign artists. France and Germany in particular came to influence his art greatly, and he lived in these countries for many years and held several exhibitions there. In his art we can recognise several of the places he lived.

At Home

At the age of thirteen or fourteen, Edvard Munch started going to art exhibitions in Kristiania (Oslo), whether at the Art Society, the art dealer Blomqvist, or the Nasjonalgalleriet, where he could see works by famous Norwegian and foreign artists. Munch painted **watercolours** and also made drawings. A few years later he started attending a technical school in order to become an architect or engineer. But he realised that he wanted to be an artist, and his father allowed him to study at the School of Drawing.

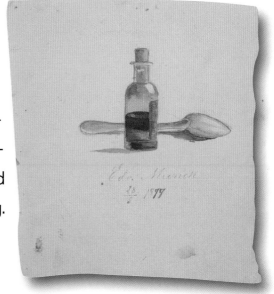

Edvard Munch, *Medicine Bottle and Spoon,* 1877. Watercolour and pencil. Munch-museet, Oslo

Munch learned a great deal about painting from what were known as "naturalist" painters, who often painted outdoors. Munch wanted to show how natural light shone on objects in his surroundings, and he added thick layers of paint to the landscape paintings where he depicted green grass, trees, and plants.

Along with other painters, Munch rented a studio right by the Norwegian parliament in central Kristiania. They served an apprenticeship with the well-known artist Christian Krohg, and experimented with different ways of painting.

The painting *Morning* shows a young girl sitting on a bed and looking toward the window, through which light streams into the room. Perhaps it is a maid who has just woken up? The morning sun makes the pitcher and the glass in the window sill seem almost transparent. The dazzling light forms the girl's body, and we see the specks of light on the linen. Munch shows an everyday scene in this painting – and such ordinary subject matter was in fact typical of the naturalists.

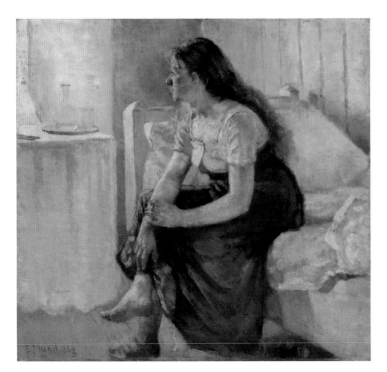

Edvard Munch, *Morning,* 1884. Oil on canvas.
Rasmus Meyer's Collections, Bergen Kunstmuseum

Abroad

He walked over to the painting at the end of the wall. It was entirely different from anything else he had seen up till then. The sun was shining, and there was a young woman with a parasol, along with a young boy strolling through a flowery meadow. He could almost smell the sweet aroma of the wild flowers. White clouds had gathered in the clear-blue sky. The painting had been done with many small, rapid brushstrokes. Munch took a step forward and examined the signature. What was the artist's name? Monet... He had to remember that name.

In Paris

As a young man, Munch travelled to Paris. Artists from many different countries settled there to go to art schools or visit exhibitions and museums. Munch soaked up all the impressions from the large, exciting city.

It was in Paris that Munch became familiar with **Impressionism**. In the painting *The Seine at Saint-Cloud*, Munch depicts the view from his room toward the Seine, the river that runs through Paris. He shows how much the lighting and atmosphere change throughout the day. Munch painted several pictures from the same position. His brushstrokes are short and dense – he is experimenting with the new style of painting he had seen from the Impressionists, as for example the French painter Claude Monet.

Photograph from the Studio of Léon Bonnat, Paris, 1889.
Photographer unknown. Munch-museet Archives, Oslo

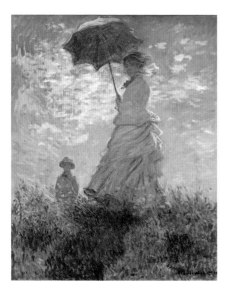

Claude Monet, *Woman with a Parasol, Madame Monet and her son*, 1875. Oil on canvas. National Gallery of Art, Washington, D.C.

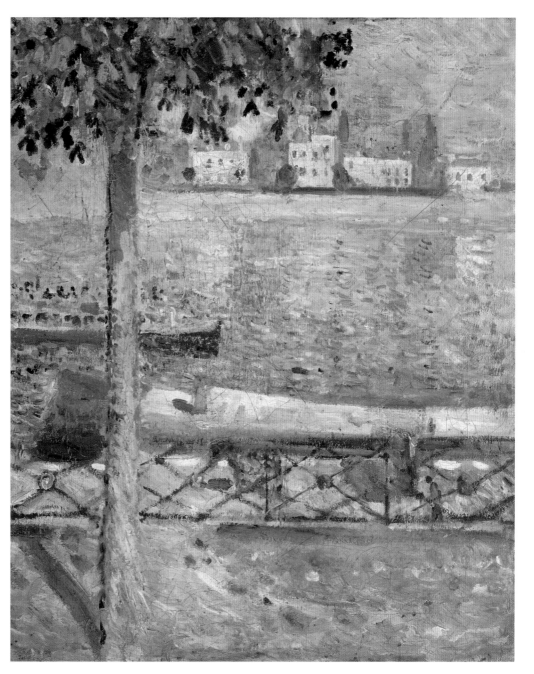

Edvard Munch, *The Seine at Saint-Cloud*, 1890. Oil on canvas. Munch-museet, Oslo

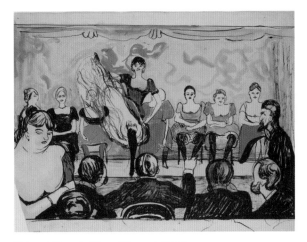

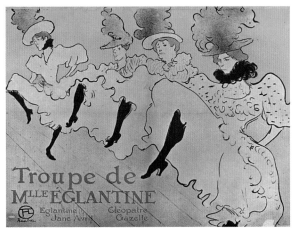

Edvard Munch, *Tingel-Tangel*, 1895.
Hand-coloured lithograph, Munch-museet, Oslo

Henri de Toulouse-Lautrec, *Miss Eglantine's Troupe*,
1896. Colour lithograph/poster

Three World-Famous Artists

When Munch lived in Paris, he saw pictures by artists who today are very well known. Three of these were Henri de Toulouse-Lautrec, Vincent van Gogh, and Paul Gauguin.

Munch made prints that bring to mind Toulouse-Lautrec's lithographs. *Tingel-Tangel* shows a cabaret, a sort of dance theatre that was popular in Paris at the time. A chorus girl dances on stage while seven others sit behind her, waiting their turn. If you compare that print with Toulouse-Lautrec's *Miss Eglantine's Troupe,* the yellow and orange colours are the same, and both Munch and Toulouse-Lautrec use clear, bold lines, or contours, to frame the various shapes. The pictures have almost been made as caricatures in that Munch and Toulouse-Lautrec exaggerate in order to make the people look comical. Toulouse-Lautrec's

picture was an advertisement that was posted at different places around Paris, and Munch may well have seen it when he lived there.

Van Gogh and Gauguin were also important sources of inspiration for Munch when he was young. *The Night Café* is one of van Gogh's most famous paintings. He often used **complementary colours**, such as red and green here, and a dramatic perspective that draws our gaze into the picture. Think of how our eyes follow the lines of the railing far back into Munch's *The Scream* – Munch also contrasted lively, complementary colours in many of his paintings.

Similar to van Gogh, Gauguin also divided his paintings into large, clearly defined fields of vibrant colour. He simplified shapes instead of painting every single detail.

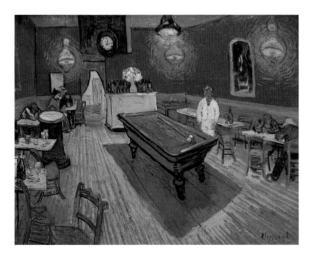

Vincent van Gogh, *The Night Café*, 1888. Oil on canvas. Yale University Gallery, New Haven

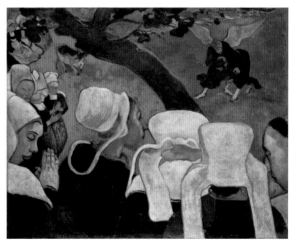

Paul Gauguin, *Vision After the Sermon (Jacob Wrestling with the Angel)*, 1888. Oil on canvas. Scottish National Gallery, Edinburgh

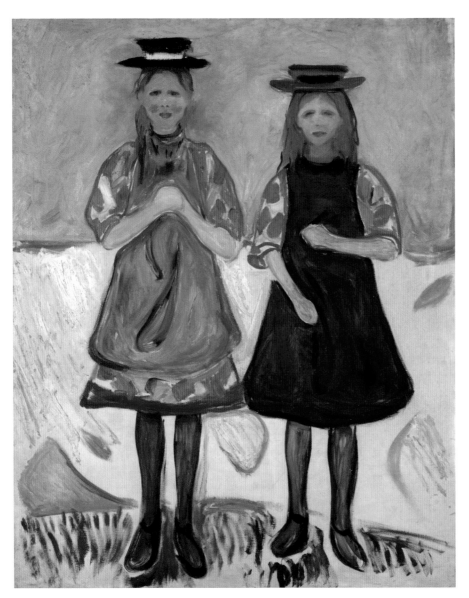

Edvard Munch, *Two Girls with Blue Aprons*, 1904–05.
Oil on canvas. Munch-museet, Oslo

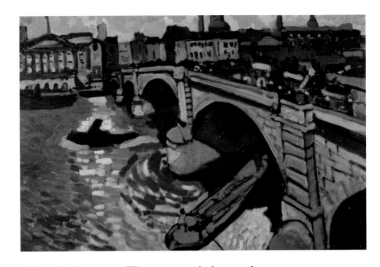

André Derain, *London Bridge*, 1906.
Oil on canvas. Museum of Modern Art, New York

The "Wild Beasts"

Munch exhibited his paintings in Paris along with a group of artists who were known as *Les Fauves*, which in English means "The Wild Beasts". Similar to the three artists mentioned above, the *Fauves* also used vibrant colours and simplified shapes. They used the **primary colours** red, blue, and yellow, and they brought life and excitement to their pictures by using bright, complementary colours together (see for example Derain's *London Bridge*).

In Munch's *Two Girls with Blue Aprons*, we see two young girls from the Norwegian village of Åsgårdstrand. Their dresses have been reduced to triangles, and the girls as well as the background are painted in clear blue, red, and ochre-yellow hues. Just like the *Fauves*, Munch simplifies the forms.

In Berlin

At the Association of Berlin Artists, an exhibition of Munch's pictures was closed in protest after only one week – and his name began to spread as a result. People thought his paintings were ugly. Munch lived in Germany for many years and returned several times later on to exhibit his paintings there.

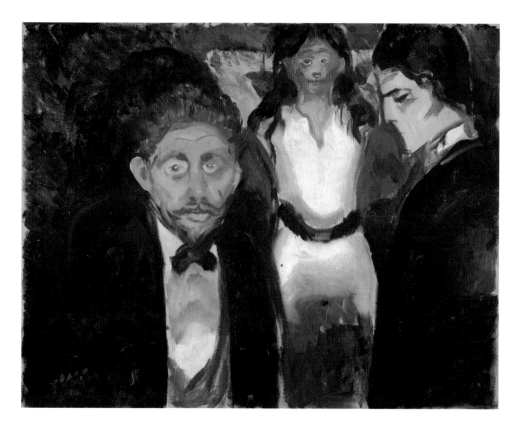

Edvard Munch, *Jealousy*,
1907? Oil on canvas.
Munch-museet, Oslo

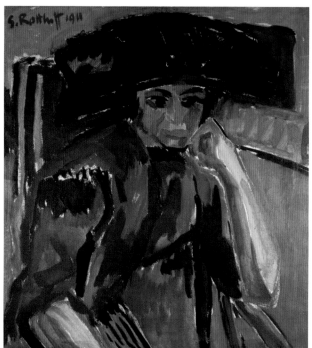

Karl Schmidt-Rotluff,
Portrait of Rosa Schapire,
1911. Oil on canvas.
Brücke-Museum, Berlin

Quite a few German artists were interested in Munch's art. They saw how he used vibrant colours and simple forms with clear contours, just as Munch himself had seen the French artists do.

Many of Munch's paintings communicate strong feelings, such as love, jealousy, anxiety, and sorrow, which are expressed through colours and **symbols**. Munch is often called a pioneer of the style known as **Expressionism**. The Expressionists would paint the sky red or a face green. Whether it was realistic or not was beside the question – rather, the artists wanted to highlight certain feelings and moods.

How Did Munch's Surroundings Affect His Art?

He wandered barefoot along the long, beautiful beach. The waves made his feet wet and left tiny wisps of foam on his toes. Over there was the rock where Munch had painted his friend Jappe. Quivering, rust-brown seaweed was driven ashore, to be baked in the sun when the high tide receded. This is where he had strolled alongside the woman he was in love with, while the wind swept through her hair. He wanted to paint her in white, red, and black and show all the sides of passion and love, including the sad ones. And he wanted to paint her with closed eyes on the beach, with the moon reflected in the blank fjord.

Munch often used the places where he lived as the backdrop to his pictures. Some of these pictures are pure landscape paintings, while other pictures contain **symbols** that suggest he has intended something more than just painting the scenery.

Åsgårdstrand: The Yellow House and the Summer Night

Many of Munch's best-known images are taken from the tiny village of Åsgårdstrand on the western side of the Oslofjord. He bought a yellow house there that we can see in several of his paintings. The house was located next to a curvy shoreline that we can recognise in both *Separation* and *Melancholy*, where a young man sits on the beach, looking sad and thoughtful.

Right next to Munch's house was a large white building known as the Kiøsterud house. A huge linden tree stood in front of the house, and a long steamer wharf stretched out from the shore. All of these things can still be found there today. Munch painted the house, the wharf, and the tree in the world-famous picture *The Girls on the Bridge*.

Kragerø and Hvitsten: The Sun and the Oak Tree

After living abroad for many years, Munch returned to Norway by sea. When the boat sailed past Kragerø, he decided that he wanted to live there. He rented a

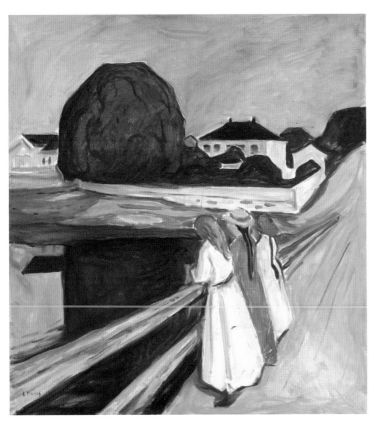

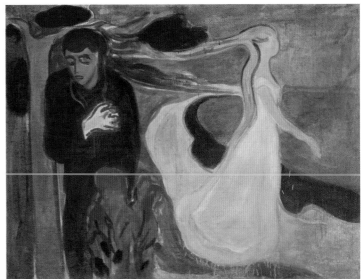

Edvard Munch, *The Girls on the Bridge*, 1927. Oil on canvas. Munch-museet, Oslo

Edvard Munch, *Separation*, 1896. Oil on canvas. Munch-museet, Oslo

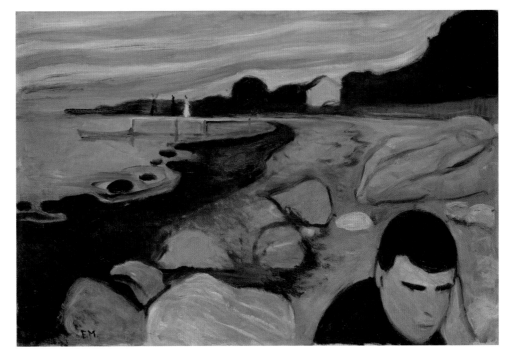

Edvard Munch, *Melancholy*, 1892. Oil on canvas. Nasjonalmuseet for kunst, arkitektur og design, Oslo

Edvard Munch painting *The Sun*, Kragerø, 1911. Photographer: A.F. Johansen. Munch-museet Archives, Oslo

The University Aula, Oslo ▶

plot of land, known as Skrubben, with a large house, garden, and view of the coastal landscape. While he lived there, he participated in a competition to decorate the University's Aula, or festival hall, in Karl Johan Street in Kristiania. He ultimately won the competition, but not without various squabbles and fierce opposition.

The paintings that he submitted to the competition were the gigantic *History* and *The Sun*, which were inspired by the natural landscape around Kragerø. *The Sun* is over four and a half metres tall and almost eight metres wide! It was so large Munch painted it in his outdoor studio, and even had to use a step-ladder to paint the upper parts.

Edvard Munch, *The Sun*, 1911. Oil on canvas. ▶
The University Aula, Oslo

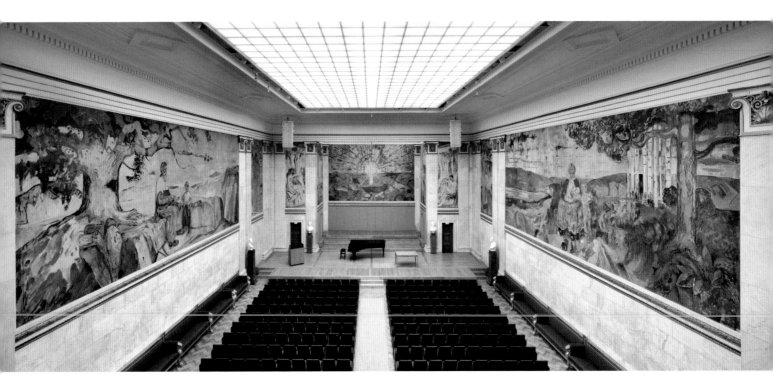

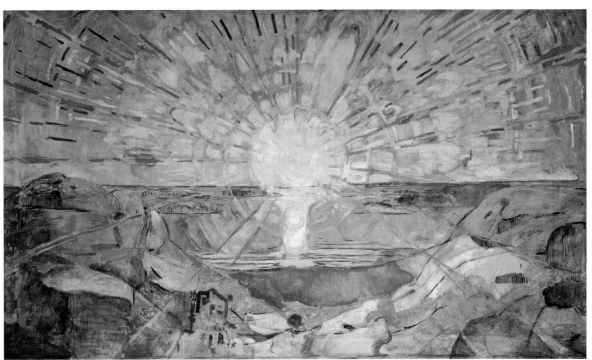

The following year Munch moved to Nedre Ramme farm in Hvitsten on the eastern side of the Oslofjord. That is where he painted *Alma Mater*, one of the other large-scale paintings hanging in the Aula. *Alma Mater* is Latin for "nourishing mother", and the painting shows a mother breastfeeding a tiny infant while older children play around them.

Ekely: The Starry Night and the Elm Forest

Munch later moved to Ekely outside of Kristiania, where he lived right until his death. He lived in a large, yellow house and used several of the rooms there as a studio. The house was jam-packed with paintings that he had kept, and he also continued to paint new ones. After a while he built further outdoor studios of wood as well as a winter studio of brick, so that he could work even if it was cold outside. From his veranda he had a view of the city, the fjord, and the hills. He painted the lush apple trees at Ekely, and a series of pictures of a forest of elms throughout the various seasons. One of the most important paintings from this period is *Starry Night*, where we see the view towards the city and the stars in the sky on a cold winter's night.

The house at Ekely was torn down a few years after Munch died, but his winter studio remains and is open to visitors. Concerts and exhibitions are occasionally held there, but normally artists who have rented the studio are working there.

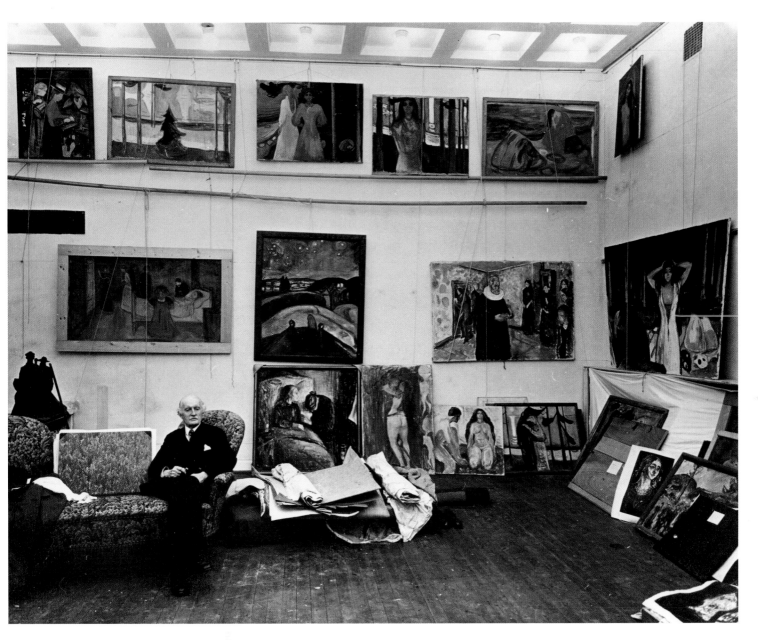

Edvard Munch in his studio at Ekely on his 75th birthday,
1938. Photo: Væring. Munch-museet Archives, Oslo

Edvard Munch's villa at Ekely.
Photo: Væring. Munch-museet Archives, Oslo

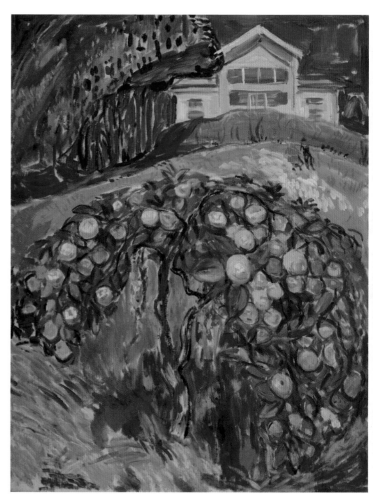

Edvard Munch, *Apple Tree in the Garden*, 1932–42.
Oil on canvas. Munch-museet, Oslo

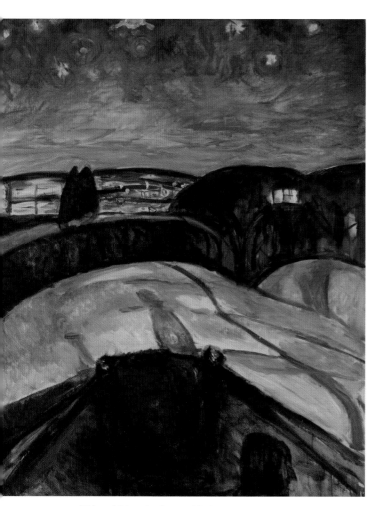

Edvard Munch, *Starry Night*, 1922–24.
Oil on canvas. Munch-museet, Oslo

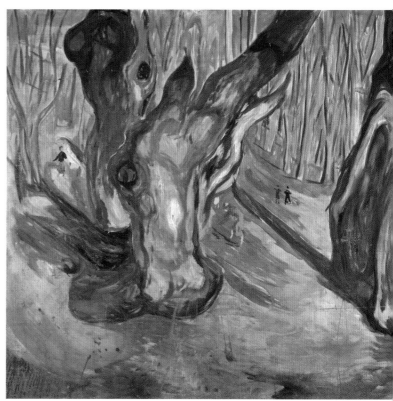

Edvard Munch, *Elm Forest in Spring*, 1923–25.
Oil on canvas. Munch-museet, Oslo

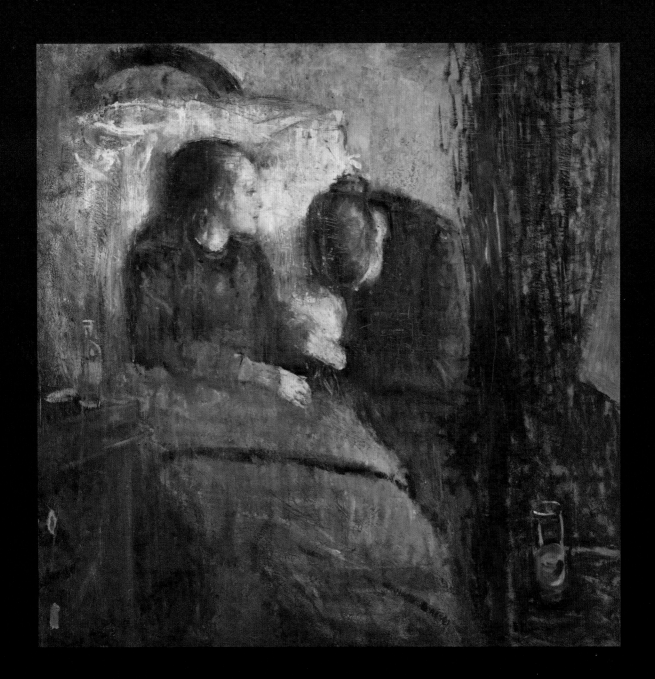

Sivert Thue

Munch's Techniques

One of the reasons Munch became such a famous artist was that he continuously experimented and worked on renewing his art. He used many different artistic techniques. Munch is mostly known as a painter, but did you know that he was also skilled at making drawings and prints? Furthermore, he wrote stories, journals, and poetry, was an enthusiastic photographer at certain periods in his life, and experimented with film.

The Sick Child

He laid his brush to rest and stared at the canvas. How was he to paint his sister exactly as she had been on the final morning of her lengthy illness? Her face had been light and translucent, the whiteness of her skin contrasting with the redness of her hair.

He had worked for such a long time, but his model showed no signs of fatigue. Her gaze was directed toward something far in the distance. He tried

◀ Edvard Munch, *The Sick Child*, 1885–86. Oil on canvas.
Nasjonalmuseet for kunst, arkitektur og design, Oslo

once more. This time he would succeed! Other people would be able to understand and experience what he had gone through.

Munch as a Painter

Similar to fashion, what is considered to be good art varies with time. In some periods artists try to create paintings that are as detailed and realistic as photographs. In other periods they try to express their feelings, without focusing so much on details or on how the objects in their painting really look.

In November 1880, right before Munch turned seventeen, he wrote in his diary: *I have again dropped out of technical school, because I have decided I want to become a painter.* At the time, **Realism** was the dominant style of art in Norway, meaning that artists would paint pictures that were so realistic that they almost looked like photographs. The idea was that the artist should paint what he or she saw – nothing more, nothing less. But this was not enough for Munch: what was the point of a painting that looked like a photograph? In that case, the artist might as well just *take* photographs. *The camera can't compare with the brush and the palette as long as it can't be used in heaven and hell*, Munch wrote in one of his notebooks.

Munch was more concerned with everything the camera *couldn't* capture: what do people dream about? What do they feel? What are the forces that govern our lives?

Colour photography had yet to be invented when Munch was establishing himself as a painter, and precisely colours were one of Munch's strong points. He was a master of colour, and the colours in his paintings often have a symbolic meaning: red represents love and passion, black is associated with sorrow and death, while white is the colour of youth and innocence.

Colour was an excellent tool for an artist who wanted to communicate emotions and dreams. Furthermore, Munch also experimented with his method of painting. For instance, he could let the paint run down the canvas, as in the painting *The Murderer*, or he could thin out the paint with turpentine, so that the underlying canvas could be seen behind the painting.

Edvard Munch,
The Murderer, 1910,
detail.
Photo: Munch-museet,
Oslo

Munch created many wonderful paintings, including two major projects that have become extra famous. The first is a series of paintings later known as *The Frieze of Life*. His other major project was to decorate the University of Oslo's Festival Hall, known as the Aula. The Aula is spacious, and Munch had to order giant, custom-made canvases from abroad. The canvases did not fit in an ordinary studio, so Munch built an outdoor studio in Kragerø. In the picture below we see Munch painting one of these giant pictures.

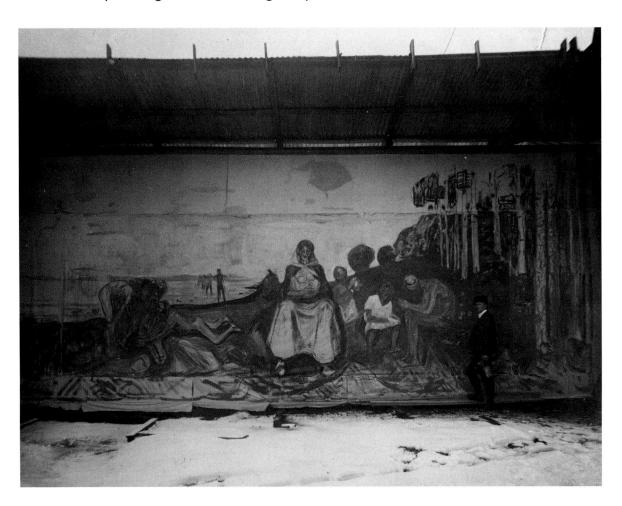

Munch as a Printmaker

That a work of art is original can mean one of two things: either that the work of art is innovative, that is, that no one ever created anything like it before, or that the work of art is genuine and not a replica.

Printmaking is a technique that allows the artist to print several copies of a picture. All of the copies are nonetheless considered to be originals, in the sense that they are genuine works of art and not replicas. Prints were important to Munch: by making several copies of a certain work, he could sell some of them and thereby earn a considerable income. When Munch gradually started to gain fame as an artist, he increasingly sold prints rather than paintings – he preferred to keep his paintings for himself. Munch worked with three main types of prints: woodcuts, etchings and drypoints, and lithographs.

The Woodcut

When an artist cuts an image into a block in order to create a picture, it is called a woodcut. After using special knives to create the image, the artist then covers the block with ink, places a sheet of paper over the block, and then runs the sheet through a printing press. The image on the block of wood is thereby printed on the sheet of paper. The process can be repeated in order to create further copies of the print.

◀ Edvard Munch in front of *The Researchers*. Kragerø, 1910.
Photo: A.F. Johansen. Munch-museet Archives, Oslo

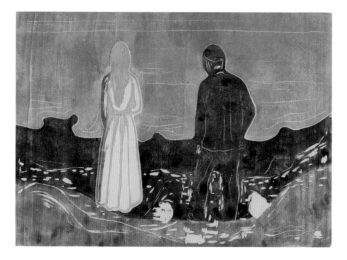

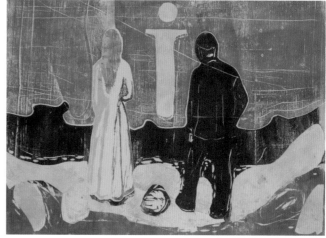

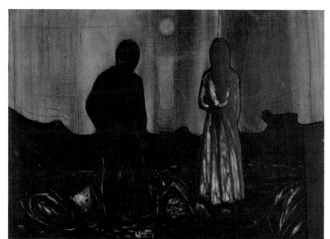

Edvard Munch,
Two Human Beings.
The Lonely Ones,
1899/ca. 1917. Woodcut.
Munch-museet, Oslo

Edvard Munch, woodblock
of birch wood for the motif
Two Human Beings.
The Lonely Ones, 1899.
Munch-museet, Oslo

Edvard Munch,
Two Human Beings.
The Lonely Ones.
Woodcut. Printed around
1917. Munch-museet,
Oslo

The block of wood resembles a jigsaw puzzle. This is because Munch has indeed used a jigsaw to carve out part of the block. Munch was one of the pioneers in this area. He was also one of the first artists to use the wood's natural pattern as part of the artwork itself. As we can see, the woodcut has been printed in both fairly neutral colours and in more vibrantly colourful versions.

The Art of Etching and Drypoint

In these techniques the artist uses a metal plate, made of either copper or zinc, and incises the image into the plate with the help of a needle. This can be done directly on the plate (drypoint), while etching is a bit more complicated and requires the use of wax and acid. After covering the plate with ink, the artist then wipes the plate so that the ink only remains in the shallow lines. A printing press is used to press a sheet of paper hard onto the plate so that the image is transferred to the paper.

The Lithograph

The word lithograph stems from the Greek word *lithos* (stone), and in this technique it is precisely a stone that is the printing plate. The artist uses a special type of fat-based crayon to create an image on a flat limestone. When the stone is moistened, the printer's ink only sticks to the areas covered with crayon fat, while the wet stone rejects it. Finally, the artist puts a sheet of paper on the stone and runs the paper through a printing press.

Edvard Munch, litographic stone with the motifs *Jealousy I* and *The Urn*, 1896. Munch-museet, Oslo

Munch as a Draftsman

When Munch worked to become an artist, he drew everywhere and all the time. He often carried a sketchbook and a pen or a pencil around with him in his pocket. At a café, on the train, or a park bench, at home in his living room or out in the forest – wherever he was, Munch would take out his sketchbook. At the Munch-museet there are almost 150 sketchbooks that are filled with Munch's drawings. Some of them are fairly worn out – you can clearly see that he has carried them around with him.

Edvard Munch,
sketchbook from
the 1880s.
Munch-museet, Oslo

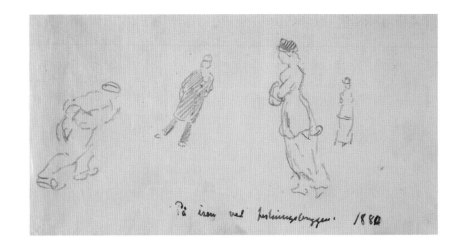

Edvard Munch, leaf from a sketchbook. *On the Ice by the Castle*, 1881. Munch-museet, Oslo

And exciting images popped up everywhere he went! In the woods he would come across beautiful stretches of nature; in the city itself he might walk past an outdoor ice rink and be fascinated by the skaters effortlessly zooming around one another.

Just as we take pictures with our cell phones today, Munch used his sketchbook to create and store images. At the same time, drawing served as a continuous exercise in depicting the things that he saw. But the drawings were far from merely being sketches and drafts of images that would later be developed as paintings – rather, they are often works of art in their own right. The shapes and lines were more important in the drawings than colour. A drawing can be more immediate than a painting, and we see how precise Munch was when capturing what he saw in only a few lines.

The Munch-museet in Oslo holds around 7,500 drawings, and many of them are fascinating works of art that reveal a less known side of Munch.

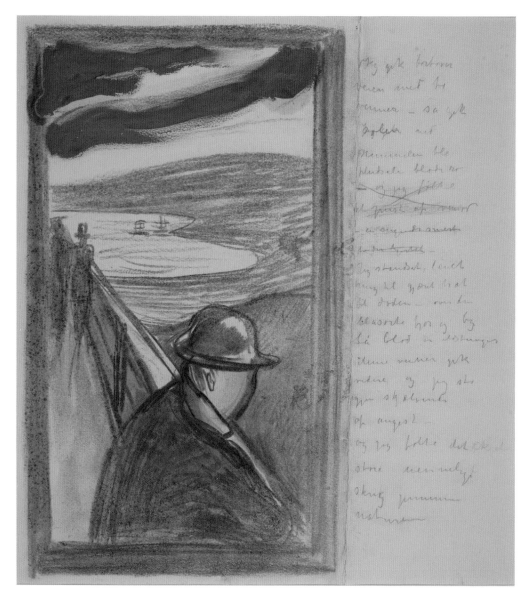

I was walking down the
road with two friends –
then the sun set – the
sky suddenly grew
blood-red – I stopped,
leaned on the fence
deadly tired – above
the bluish-black fjord
and city hung blood
and tongues of flame –
my friends walked on
and I stood where I
was quaking with
angst – I felt as though
a vast endless scream
rang out through
nature –

Edvard Munch, *Despair*,
1892. Charcoal and oil.
Munch-museet, Oslo

Munch as a Writer, Photographer, and Filmmaker

During his long life, Munch wrote many thousand pages of text, but his writings were never published in book form while he lived. Munch wrote letters, diaries, poems, and stories, and he recorded his ideas about art. As was the case with all the techniques that Munch used, he also experimented in his writing. Munch has also described personal experiences that relate to several of his most famous works, such as *The Scream* (see the opposite page).

When is the last time you wrote a letter? Phones, text messages and e-mail have taken over the role that letters played in Munch's time.

Since Munch was used to expressing himself through pictures, he also made sketches in several of his letters and postcards, usually ones to close friends. Below you can see an example of such a card: it is a Christmas card where Munch has drawn himself and his dogs next to a Christmas tree.

Edvard Munch, *Self-Portrait with Dogs and Small Christmas Three*, 1924. Hectograph. Munch-museet, Oslo

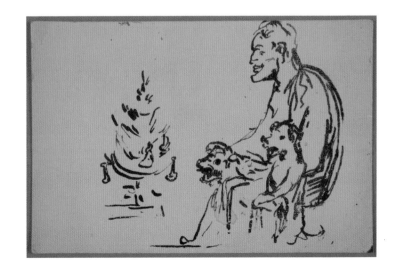

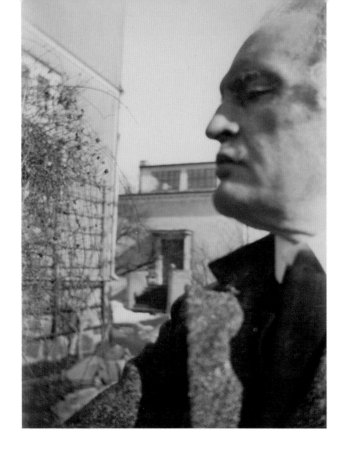

Edvard Munch,
Photographic self-portrait at Ekely, 1930.
Munch-museet Archives, Oslo
This is one of Munch's photographic self-portraits, which is not unlike a profile picture used on social media such as Facebook today

If I had owned the small, long-distance telephone that you can carry in your pocket, and that has yet to be invented, you would have received messages from me a long while ago.

Edvard Munch

Munch was fascinated by modern inventions. Perhaps that is why he experimented with photography and filmmaking? The photographs and short movies that he has left behind are not exactly major works of art, but they do testify that

Munch was an inquisitive and experimental artist. And some of his photographs, including most noteworthy his photographic self-portraits, do indeed have artistic qualities.

The New and the Timeless

Many of us are fascinated by the exciting new possibilities offered by cutting-edge technology. Nowadays we can take pictures and shoot videos with our cell phones, for example. We are almost magically attracted to things that are new. So how is it that paintings over a hundred years old can remain timeless and still move us so strongly today?

Perhaps Munch's paintings still surprise and intrigue us because as an artist he continually experimented with new techniques. Furthermore, Munch's pictures capture common human emotions and stir us just as much now as they did previous generations: people still fall in love, become ill, live, die, hate and love.

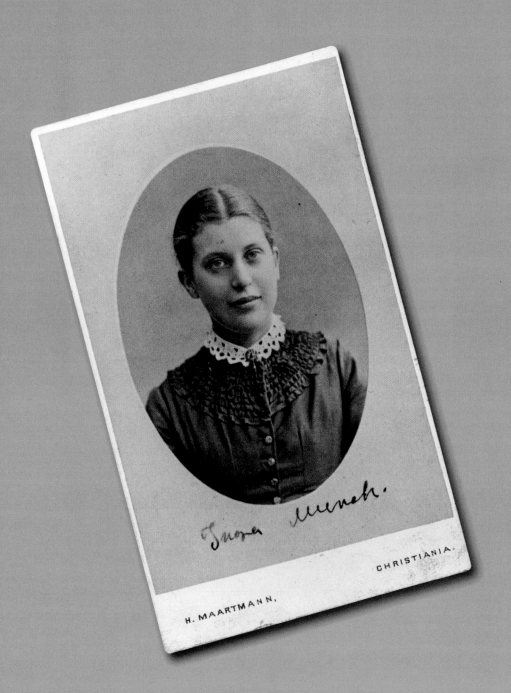

H. MAARTMANN,

CHRISTIANIA.

Inger Munch.
Photographer:
H. Maartmann, Kristiania.
Munch-museet Archives,
Oslo

Ellen J. Lerberg

People and Animals in Edvard Munch's Life

Edvard Munch the person interacted not only with other people, but with animals as well. In addition to his parents, he had several siblings and an aunt who were important to him during his childhood. In the course of his life Edvard Munch came to know many different people. To some of these he remained connected for short periods of time, while to others he remained close throughout his entire life. He painted portraits of many of the people he knew. In this chapter you can learn more about some of the people and animals in Munch's life.

Inger Munch: The Little Sister

Inger was Edvard Munch's little sister. She was five years younger than him, and she was the only one of his siblings who lived longer than him. Edvard painted several portraits of his siblings. His two portraits of Inger depict her as a serious woman, with a firm gaze and determined mouth. She almost seems a bit standoffish. As an adult, Inger lived with her aunt Karen, and both of them were convinced that Edvard would one day be a world-famous artist.

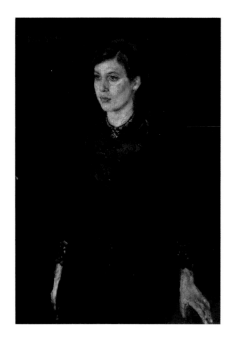

Edvard Munch, *Inger
Munch in Black*, 1884.
Oil on canvas.
Nasjonalmuseet for kunst,
arkitektur og design, Oslo

Edvard Munch, *Inger
Munch in Black
and Violet*, 1892.
Oil on canvas.
Nasjonalmuseet for kunst,
arkitektur og design, Oslo

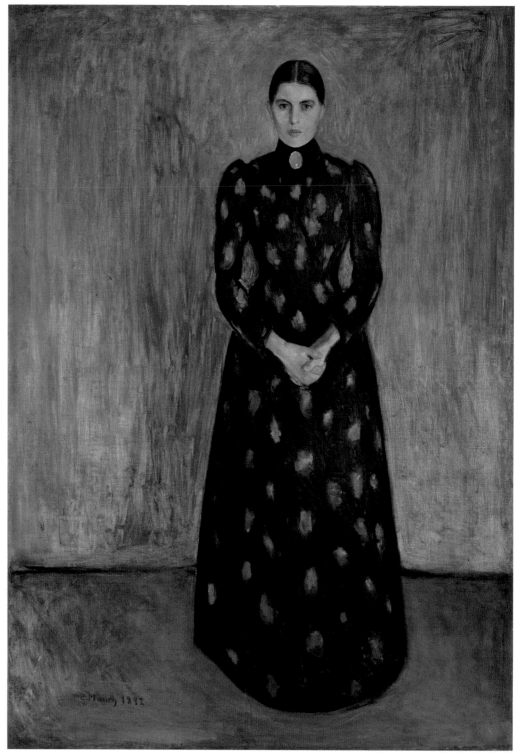

Inger and Edvard remained in close contact throughout their entire lives. Even when Inger had moved to Majorstua, only two kilometres from Edvard's residence at Ekely, they continued to write letters to each other. And Edvard sent fruits and vegetables from his garden at Ekely to Inger.

Hans Jæger: The Bohemian

Hans Jæger moved to Kristiania as a young man and got a job at the Norwegian parliament. He was also a writer, and he had strong views on a whole range of subjects – his views were in fact so strong that he felt that everyone should know about them. He therefore launched the newspaper *Impressionisten*

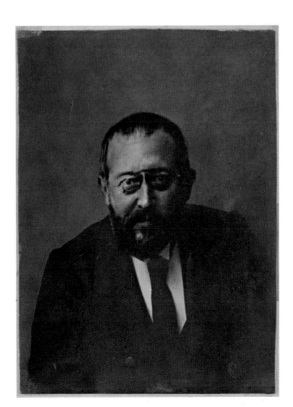

Hans Jæger.
Photographer unknown
© Picture collection,
Nasjonalbiblioteket, Oslo

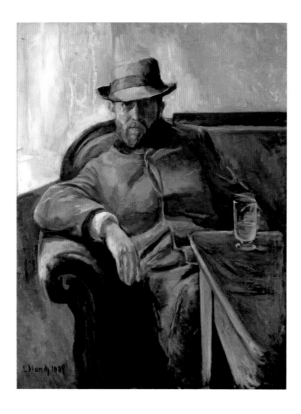

Edvard Munch,
Hans Jæger, 1889.
Oil on canvas.
Nasjonalmuseet for kunst,
arkitektur og design, Oslo

(The Impressionist) along with his artist friend Christian Krohg. Both the newspaper and the books he wrote caused a public uproar, and Jæger was sent to jail because he had written about sex (a topic you weren't supposed to talk about back then). Jæger spent sixty days in jail, but he was allowed to order food from restaurants and take his own furniture and belongings with him. Since he was free to choose, Jæger decided to decorate his jail cell with paintings by Munch.

Jæger is known for his nine so-called bohemian commandments, the first of which was, *You shall write about your own life*. This inspired Munch to begin writing a diary, and he also wrote something that could have become a novel. Munch

also followed Jæger's first commandment by making paintings that were based on his own life, experiences, and surroundings; many of these paintings were part of *The Frieze of Life*. Like Jæger, Munch "wrote" about his own life, but not only with words.

Dagny Juel: A Muse in Berlin

Dagny Juel moved from the small Norwegian town of Kongsvinger to the German metropolis Berlin along with her sister Ragnhild. They were going to study singing and the piano. The Juel sisters and Munch soon belonged to the circle of artists who gathered around the writer August Strindberg. Dagny was the heart and soul of this circle. She was very smart, and many of the men in the circle liked to discuss things with her, even though she was "only" a woman (this was a time when the opinions of women were largely overlooked).

Dagny Juel was a beautiful woman, and many fell in love with her – including Munch, perhaps? He painted this portrait of her, and as we clearly can see, he has attempted to depict her personality and beauty, which he shrouds in a mysterious darkness. Dagny died in 1901: she was murdered in Tblisi in Georgia, and Munch was greatly saddened when he heard the news. Even though he had not seen Dagny Juel in several years, he had many fond memories of her and their time together in Berlin.

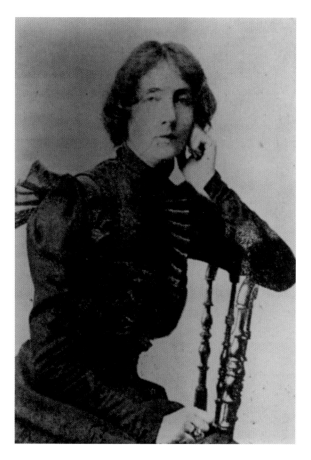

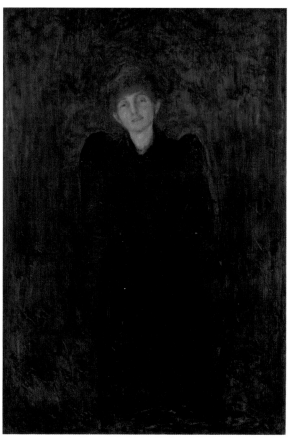

Dagny in the spring of 1901, Warsaw.
Photographer unknown.
Munch-museet Archives, Oslo

Edvard Munch, *Dagny Juel Przybyszewska*,
1893. Munch-museet, Oslo

August Strindberg: The Great Swedish Author

Edvard Munch met the Swedish writer August Strindberg in Berlin in 1892. Strindberg was at the time the central figure of a group of friends who used to gather at the tavern *Zum schwarzen Ferkel* (The Black Piglet). Strindberg too was in love with Dagny Juel, and he even proposed to her, even though he was already engaged to marry another woman. Dagny rejected his marriage proposal, apparently stating that Strindberg was both too old (he was eighteen years older than her) and too fat. Strindberg was furious and wanted revenge, so he spread nasty rumours about Dagny, saying that she lied and often had several boyfriends at the same time. Fortunately, Strindberg's rumours were soon exposed as false.

Munch made several portraits of Strindberg. One is a black-and-white print, where Strindberg looks straight at us. Around him is a decorative border where

August Strindberg, 1879.
Photo: C. & I. du Jardin,
Stockholm.
© Strindbergsmuseet,
Stockholm

Edvard Munch,
August Strindberg, 1896.
Lithograph.
Munch-museet, Oslo

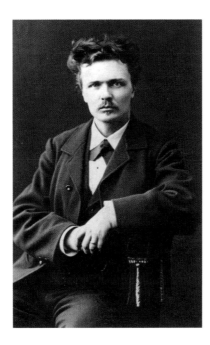

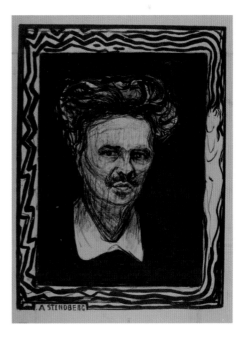

the name "Strindberg" has been inscribed, but it is missing an *r*. Strindberg was absolutely fuming that Munch had spelled his name wrong – had Munch done it to tease him? Munch made a new version of the portrait with Strindberg's name spelled correctly, but Strindberg had a vicious temper and never forgot Munch's misspelling. One time he wrote to Munch, "The last time I saw you, I thought you looked like a murderer – or at least like a murderer's henchman."

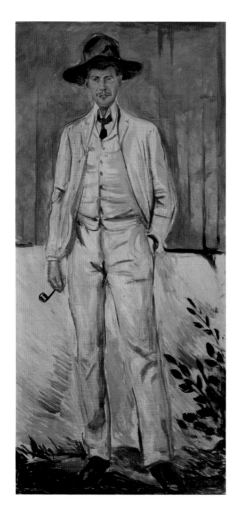

Edvard Munch, *Ludvig Karsten*, 1905. Oil on canvas. Thielska Galleriet, Stockholm

Ludvig Karsten:
The Young Norwegian Artist

Ludvig Karsten was also a painter, and he admired Munch's art greatly. In the summer of 1905 he visited Munch in Åsgårdstrand. Both men enjoyed parties, and soon it was time to celebrate Midsummer Eve. After quite a few glasses of both wine and beer, Karsten and Munch started quarrelling. It's not entirely clear what exactly they were arguing about, but things quickly got out of hand, and that Midsummer Eve in Åsgårdstrand ended in a mighty scuffle: Munch and Karsten attacked each other in a flurry of fists, resulting in a broken wrist, a bloody nose, and a summer suit splattered with blood. Though they were no longer

Edvard Munch, *The Fight*,
ca. 1916.
Hand-coloured etching.
Munch-museet, Oslo

friends after that, Munch still thought Karsten was a gifted painter, and several years later Munch made paintings and etchings of their fight.

Henrik Ibsen: The Global Celebrity

During an exhibition of his paintings at Blomqvist's Art Gallery in Kristiania in 1895, Munch met the world-famous Norwegian playwright Henrik Ibsen. Several years later, in 1929, Munch wrote the following with a note of pride: "One day I saw Ibsen at the gallery. He walked over to me. 'This is highly interesting,' he said. […] He insisted I walk with him, and he wanted to see each and every picture. Many of the paintings from *The Frieze of Life* were being displayed."

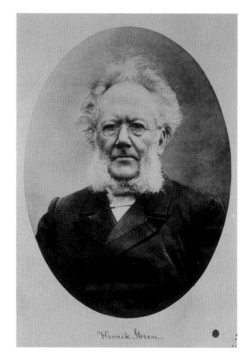

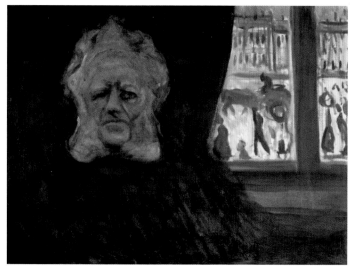

Henrik Ibsen. Photographer unknown.
Munch-museet Archives, Oslo

Edvard Munch, *Henrik Ibsen at the Grand Café*, 1898.
Oil on canvas. Private collection

So Munch himself guided Ibsen around his paintings. There was a large age gap between the two men: Ibsen was thirty-five years older than Munch, but that did not prevent them from being interested in the same important questions about what it means to be human. Ibsen's many plays about the relationship between men and women, about despair and worry, have much in common with Munch's works. Both Munch and Ibsen had been ridiculed and received negative reviews in the newspapers, and it was probably inspiring to Munch that Ibsen had had such a successful artistic career despite it all.

Munch painted a portrait of Ibsen. He is sitting in the Grand Café in Kristiania; through the window in the background we look out on Karl Johans Gate, where Ibsen would take a stroll every single day on his regular route between Arbinsgate, where he lived, and Grand Café.

Munch was for a long while keenly interested in Ibsen's writing, and made prints and drawings that were inspired by several of his plays.

Jappe Nilssen: The Friend and Journalist

Munch and Jappe Nilssen had known each other since they were young men in Kristiania. Jappe became a journalist, and specialised in writing about art in newspapers, *Dagbladet* in particular. Jappe wrote about several of Munch's exhibitions, and when Munch came home to Norway in 1909 after having been in hospital in Copenhagen, Jappe was a good friend to hang around with in Kragerø.

Jappe was one time in love with a woman named Oda, which was no easy matter because Oda was already married. Jappe spoke to Munch about his plight, and Munch painted the story in a picture he titled *Melancholy* (p. 29). In the painting we see a man – perhaps

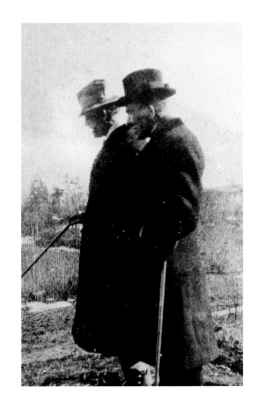

Jappe Nilssen and Edvard Munch, ca. 1930. Photographer unknown. Munch-museet Archives, Oslo

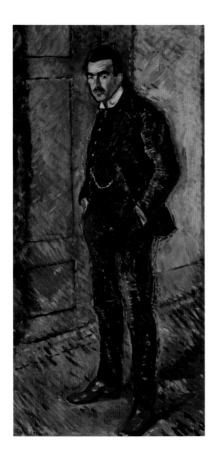

Edvard Munch, *Jappe Nilssen*,
1909. Oil on canvas.
Munch-museet, Oslo

Jappe? – who sits on the beach, while in the background a man and a woman are walking together on a pier. The woman might be Jappe's lost love Oda, and the man is perhaps her husband.

During that summer in Kragerø in 1909, Munch painted a portrait of Jappe. This is one of several full-length portraits Munch painted of friends and acquaintances that year. He later called this series of portraits "the bodyguards of my art". Munch and Jappe Nilssen were friends all the way until Jappe died in 1931. They had known each other for almost forty years.

Jens Thiis: The Museum Director

Jens Thiis and Munch frequented each other almost their entire lives. They got to know each other when they took drawing courses together as young boys. Later on they met again in Berlin, and when Thiis became the director of the Nasjonalgalleriet, he came to play an important role for Munch's career. Many of Munch's most important paintings were acquired by the Nasjonalgalleriet while Thiis was its director, and it was mainly because of him that

Munch received the commission to decorate the University Aula in the capital. It was also Thiis who was behind the largest exhibition of Munch's art to be displayed in Norway while he still lived; that took place in the Nasjonalgalleriet in Oslo in 1927.

Thiis had for a long while thought about writing a major book about Munch, and for that he needed solid information. He received such information from Munch himself, usually by letter. Munch was fairly strict with Thiis, because he wanted the book to be truthful but without revealing too much: Munch had become famous, and had definite ideas about how he should be perceived and remembered. Munch was pleased in the end, and Thiis was very proud of his book.

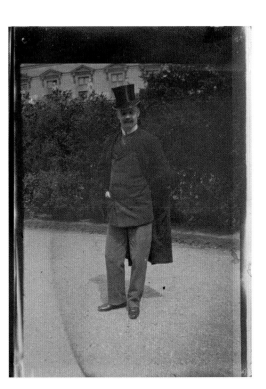 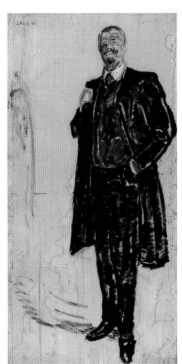

Jens Thiis.
Photographer unknown.
Nasjonal-biblioteket, Oslo

Edvard Munch, *Jens Thiis*,
1909. Oil on canvas.
Munch-museet, Oslo

Thiis said himself that he was an expert on the Munch family, and that no one else knew more about the subject than himself.

But Thiis and Munch were not always such good friends. When Thiis and his family received a crate of apples from Munch's garden at Ekely, it turned out that almost all the apples were spoilt. In his "thank-you note", Thiis asked Munch not to send them rotten apples the next time …

Tulla Larsen: The Girlfriend

When Munch was thirty-four, he met Tulla Larsen. They soon became a couple, and in 1899 they travelled to Italy together. They were passionately in love! But then Munch fell ill – seriously ill. He coughed and wheezed, had a fever, and was in pain. Tulla was patient and took as good care of him as she could. She ran errands, gave him food and medicine, and put a cold rag on his forehead when he needed it. Munch began to have second thoughts: he could no longer work in the way he wanted to! His love for Tulla Larsen was also waning, and he began to wonder whether being together with her could hinder him and disrupt his art. Perhaps it would be better if Tulla travelled home in advance? So she travelled north to Paris and waited for him there.

In Paris Tulla met other Norwegians, such as the author Gunnar Heiberg. Munch could not stand Heiberg, so you can imagine his jealousy! He *wanted*

Tulla Larsen. Photographer unknown. Munch-museet Archives, Oslo

Edvard Munch, *Tulla Larsen*, 1898–99. Oil on canvas. Munch-museet, Oslo

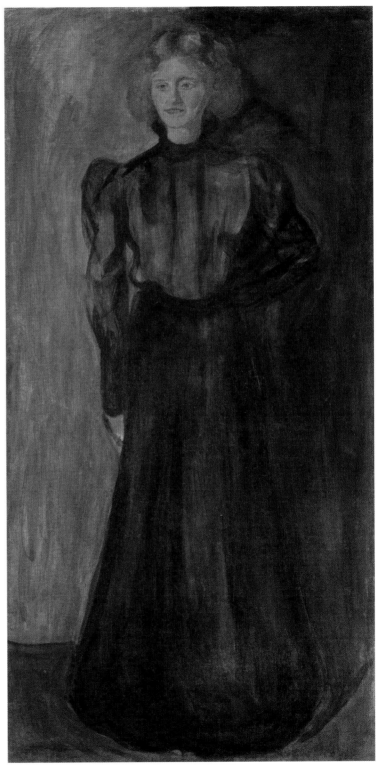

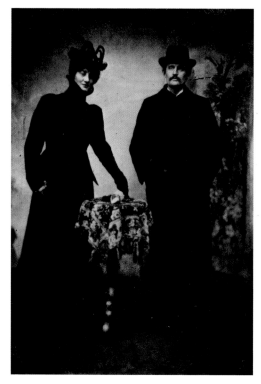

Edvard Munch with his fiancée Tulla Larsen, ca. 1899. Photographer unknown. Munch-museet Archives, Oslo

Tulla as his girlfriend, and he *didn't* want her as his girlfriend. And that is how he went, back and forth, back and forth – he could never make up his mind, and it drove Tulla crazy. Munch wrote her many letters: *The impossibility lies in our entirely different outlooks on life – You were raised in joy, appreciating life [...] I grew up with sorrow, tragedy, and disease – and I have therefore gained the opposite viewpoint on life – You believe that you understand me and my pictures – but you never have.*

It was first in 1902, after several years of doubt and uncertainty, that they ended their relationship, and in a highly dramatic way. Munch was at his summer residence in Åsgårdstrand; Tulla visited him, and they started to quarrel. Munch kept a revolver somewhere, and at one point he must have taken it out. A shot was fired – and hit Munch himself. The bullet lodged itself in the middle finger of his left hand. And with that shot, their intense love affair finally ended.

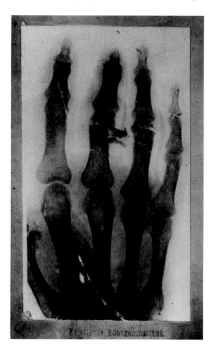

X-ray of Edvard Munch's left hand after the shooting accident in 1902. The Roentgen Institute of Kristiania (Oslo). Munch-museet Archives, Oslo

Four-Legged Friends (and Enemies)

After Munch moved to Ekely, he had many different dogs: big dogs, small dogs, furry dogs, and short-legged dogs. Munch probably spoke to his dogs every day. And he painted them, in almost the same way he painted portraits of people. Dogs have their own personality, Munch believed – and he wanted to paint that personality. He also took photographs of his dogs. When Munch lived on Jeløya, he owned a setter named Boy, whom he took to the movies. If the dog barked, Munch believed it didn't like the movie, so he and Boy would leave the movie theatre.

Gunnerud's Horrible Hound

One of Munch's neighbours at Ekely, Axel Gunnerud, owned a huge beast of a dog. The dog's name was Rolle, but Munch never used that name, instead referring to the creature as "Gunnerud's dog". It was an ill-tempered guard dog that had shredded the postman's trousers, leaped on the milk boy, bit the chimney sweep, and threatened many of the neighbours. Even though Munch was fond of dogs and was himself a dog owner, he thought that Gunnerud's dog was a menace to all. He tried to persuade the

Edvard Munch, *Dog with Muzzle,*
ca. 1921. Pen and ink.
Munch-museet, Oslo

owner to put a muzzle on the dog, or simply put it to sleep. In fact, Munch even started a petition to have the dog rendered harmless, whether through a leash, a muzzle, by having it put to sleep, or indeed anything that could prevent it from attacking people. He also reported the dog's owner to the police, and felt almost persecuted by the animal: "It was my friends and I who were its targets," he wrote.

Munch depicted his experiences with Gunnerud's dog in a number of drawings, lithographs, and paintings, including a portrait of Rolle. A black-and-brown dog looks at us in an angry, threatening manner; the dog is shown close-up, and Munch has depicted the man-hating, terrifying dog almost in the manner of a

Edvard Munch,
Dog's Head, 1942.
Oil on canvas.
Munch-museet, Oslo

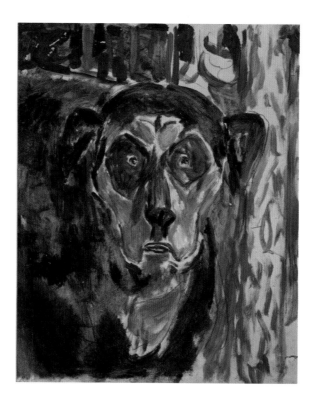

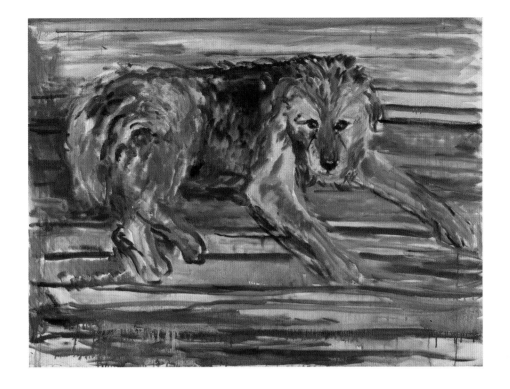

Edvard Munch, *Airedale Terrier*, 1919–20.
Oil on canvas.
Munch-museet, Oslo

normal portrait. The dog's eyes clearly have an iris that contrast with the white surrounding it, just like the human eye, and this makes the dog's gaze clearer and more expressive. The dog is depicted with hanging jowls and a downturned mouth, and even its ears are drooping. There should be no doubt about the qualities and personality of this dog!

Munch Himself

Munch's closest associate throughout his entire life was none other than Munch himself. He used this in his art, for better and for worse: he painted over

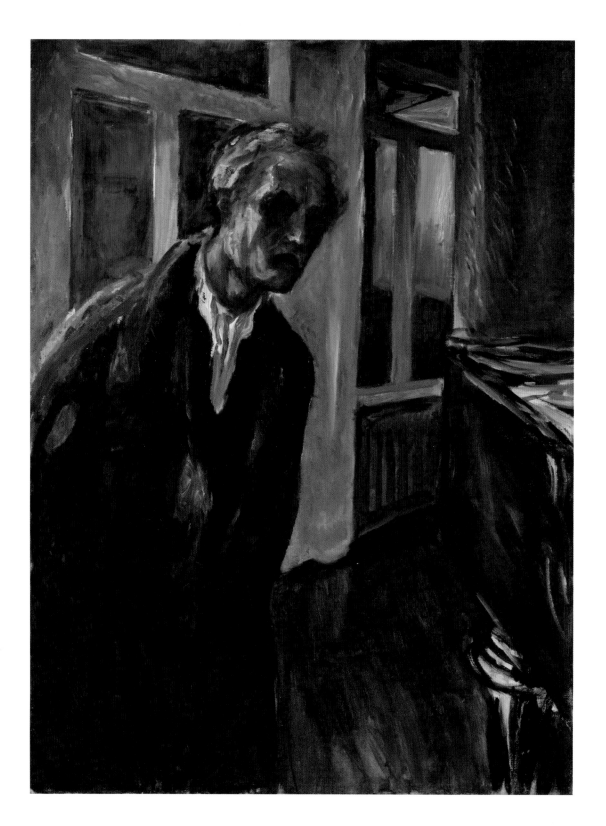

seventy self-portraits, and he often based other paintings on his own life and experiences. After leaving home as an adult, Munch never lived in close quarters with other people, and in certain periods he was almost entirely isolated.

When Munch lived at Ekely, he went through a period of being unable to sleep at night. Have you ever had nights where you couldn't sleep? Where you toss and turn in bed, where your duvet becomes too warm, your bed-sheet gets crumpled, and your pillow feels like a rock? What do you do then? For his part, Munch got up and walked about the house, looking at how all the different things appeared in the dark of night. And then he might start painting, for example a self-portrait or the view from his veranda. *The Night Wanderer* is the name of one of these self-portraits. In it we see Munch in a dressing gown, his hair all bushy. He holds his hands behind his back and leans forward. While striding through the room, he gives us a quick glance. Is he doing that to ask us to leave, to not disturb him, or to say hello?

◀ Edvard Munch, *The Night Wanderer*, 1923–24.
Oil on canvas. Munch-museet, Oslo

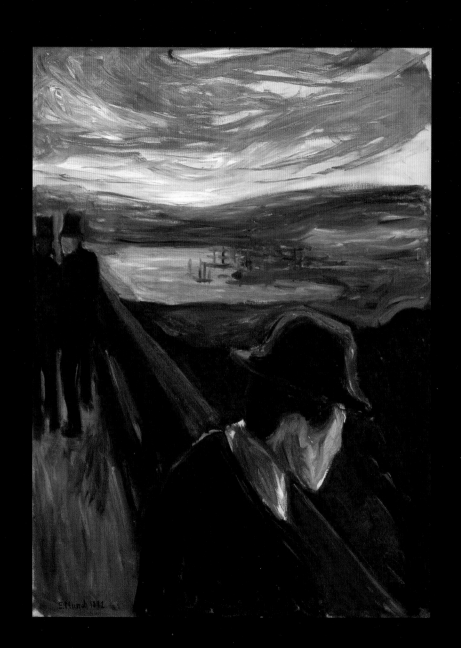

Hilde Ødegaard

The Frieze of Life:
A Series of Paintings

No longer shall interiors be painted,
or people who read or women who knit.
There shall be living people
who breathe and feel and suffer and love –
Edvard Munch (1889)

In the 1890s Munch painted experiences from earlier in his life. He painted what he remembered – he was the painter of memory. Instead of painting a model, landscape, or interior, as he had previously done, he wanted to show another side of reality, one that we cannot see, namely the inner world – the thoughts and feelings of humanity. "I do not paint what I see," Munch wrote, "but what I saw."

The Scream

In Nice in 1892 Munch painted *Sick Mood at Sunset. Despair*, which he then further developed into the painting of *The Scream*, such as we know it today.

◀ Edvard Munch, *Sick Mood at Sunset. Despair*, 1892.
Oil on canvas. Thielska Galleriet, Stockholm

The inspiration for the painting had come to him at home in Kristiania (Oslo) while going for a stroll on the Ekeberg hill with two friends.

The Scream is one of the most famous paintings in the world. It seems to have been done rapidly, but all the sketches and drafts show that Munch spent a lot of time and effort to arrive at the final expression.

Munch created several versions of *The Scream.* You can see them at the Munch-museet and the Nasjonalmuseet in Oslo. The first version of *The Scream* is from 1893, and a new version was probably painted in 1910. There are also two pastel versions of *The Scream.*

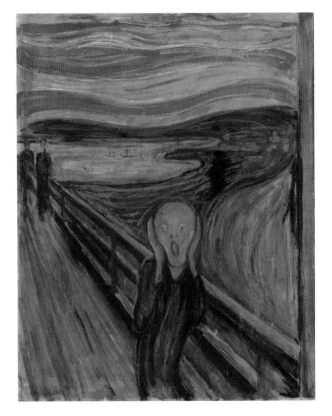

I felt like a scream throughout nature – I seemed to hear a scream. –
I painted this picture – painted the clouds as real blood. – The colours screamed. –
This became the painting The Scream *in "The Frieze of Life".*
Edvard Munch

◀ Edvard Munch, *The Scream*, 1893.
Oil and crayon on cardboard.
Nasjonalmuseet for kunst, arkitektur og design, Oslo

Edvard Munch, *The Scream*, 1910?
Oil and tempera on cardboard.
Munch-museet, Oslo ▶

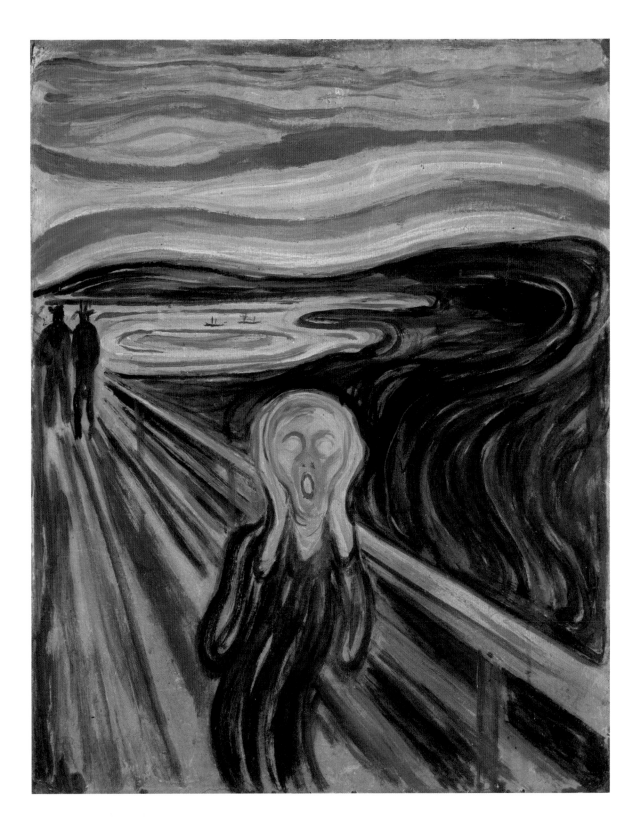

The Scream uses colours and shapes to create a sense of sound. But how could Munch paint something that you can't see, but only hear? The scream is made visible not only through the open mouth, but also through the surrounding landscape, as Munch writes. The wavering lines and the violent colours also help express the person's experience of anxiety, that is, of being nervous and afraid. The landscape expresses an internal feeling, not an external reality. *The Scream* is a picture of anxiety itself.

More than anything, the picture is about what it means to be a modern person in a modern era. "I see, I see – it seems as though I'm on the wrong planet! Things are so strange here," wrote the poet Sigbjørn Obstfelder in 1893, the same year that his friend Munch painted *The Scream* for the first time. Like Munch, Obstfelder describes a feeling of anxiety.

The Frieze of Life: A Series about Love, Anxiety, and Death

The Scream, Despair, and *Anxiety* belong to a series of pictures that Munch painted in the 1890s and that he exhibited together at an exhibition in Berlin in 1893. The exhibition included paintings such as *Death in the Sickroom*, *The Voice*, *Kiss*, *Vampire*, *Madonna*, and *Jealousy*.

According to Munch, the paintings were meant to be experienced together as a poem about love, anxiety, and death – that is, the timeless questions of

Edvard Munch, *Anxiety*, 1894. ▶
Oil on canvas. Munch-museet, Oslo

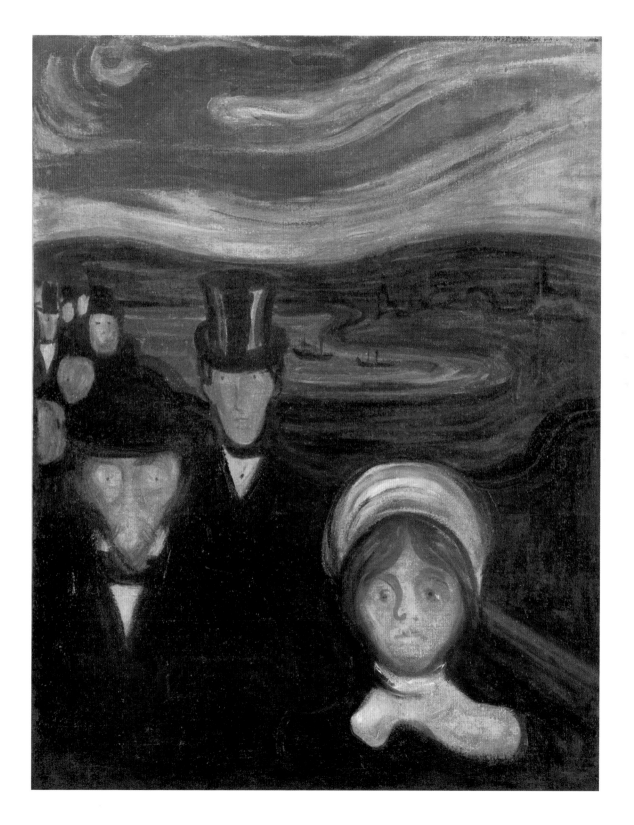

being human. A "frieze" means quite simply that the paintings form a continuous band and are presented as a series. That the paintings are associated with one another can be seen from not only their contents and themes, but also their composition.

Munch called the exhibition *Study for a series called "Love"*. Another title he used was "From the Inner Life of Modern Man" – it was first later that the series was titled *The Frieze of Life.* In a notebook Munch described why he started painting this series:

In my art I have tried
to clarify to myself life and its
meaning –
My aim has also been to help others
to clarify life
I have always worked best with my
paintings around me –
I placed them side by side and felt that
certain pictures were thematically linked with
one another –
When they were exhibited together, they

began immediately to resound, becoming something
entirely new together than by themselves
They became a symphony
That's how I came to paint friezes.

Munch repeats some of the same human figures in the various *Frieze of Life* paintings. For example, the man from *Sick Mood at Sunset. Despair* turns up again in *Separation,* while the women respectively dressed in white, red, and black reappear in several other pictures. The "moon pillar", shadow, and red

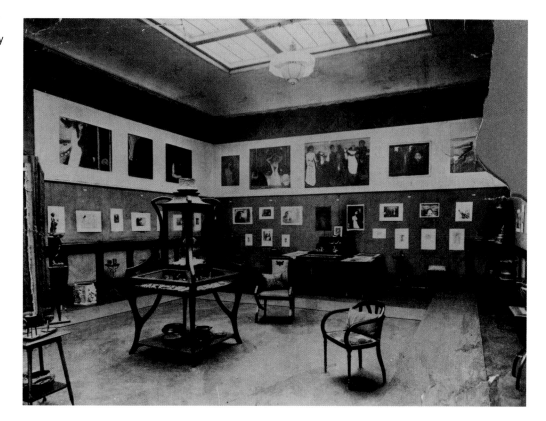

Edvard Munch's *Frieze of Life* exhibited at the gallery of Beyer & Sohn, Leipzig, 1903. Photographer unknown. Munch-museet Archives, Oslo

flower are other recurring elements. The people are depicted either outdoors in a landscape, such as on a beach or in a forest, or in a room. They are portrayed in a simplified, schematic form, making it impossible to identify them as specific people: they may represent just anybody.

Munch did not organise *The Frieze of Life* paintings in a fixed sequence. Instead, he re-arranged the paintings from one showing to the next, thus creating ever new stories. The pictures are still exhibited to this day – and each time they appear in a new context, we see them as if with a new pair of eyes.

The basis of *The Frieze of Life* paintings was Munch's own life and the times he lived in: *You do not have to search far and wide to explain the origins of The Frieze of Life – The explanation lies in the bohemian ideals – It was a matter of painting life as it was being lived, including your own life* Munch wrote. Nevertheless, the paintings are about *every* person's life. They deal with subjects that mankind has always had to deal with: love, sorrow, separation, jealousy, and anxiety.

Some Paintings from *The Frieze of Life*

Death in the Sickroom

A woman stares at us, leading us into the picture. A group of people are dressed in black. It's almost as though we can *hear* how quiet it is. The people are not speaking with one another. They avoid each other's glances and stare at the floor or into space. We do not see their facial features. The bed is empty, but in a chair to the right the sick girl sits with her back to us, concealed by the back of the chair, covered in a white blanket. While Munch in *The Sick Child* emphasises the sick girl, it is rather the grieving family that is important here.

Munch painted the picture when he was thirty, but it is the memory of the death of his sister many years before, a tragedy that had etched itself into his mind, that he is depicting. When he was thirteen, his sister fell seriously ill and died of the disease tuberculosis.

Edvard Munch, *Death in the Sickroom*, 1893. Oil on canvas. Munch-museet, Oslo

Vampire

A woman bends over a man, as though she is kissing him. His face is white, and her long, red hair cascades down, partially covering him. A dark shadow fills the background. Munch changed the title of the picture several times. At first he called it *Love and Pain*, before renaming it *Vampire*. Later on he supposedly called it simply *A Woman Kissing a Man on the Neck*. The three different titles greatly influence how we interpret the picture. Is the woman a dangerous, blood-sucking vampire, or a caring woman who hugs, comforts or simply kisses the man on the neck?

Separation

Then she stood up. I don't know why. She moved slowly away, toward the sea, farther and farther away. That's when I had the strangest sensation. I felt as though there were invisible strands between us. As though invisible strands of her hair were still wrapped around me. And even when she had completely disappeared over toward the sea, I felt how painful it was where my heart was bleeding, because the strands could not be ripped through.

<div align="right">Edvard Munch</div>

A woman in white clothes is moving away from a man, on her way toward the sea. She holds her head aloft while gazing at something far away on the horizon. Her face is entirely without features, and she seems to glide across the beach with a goal in mind.

Edvard Munch, *Vampire*,
1895. Oil on canvas.
Munch-museet, Oslo

Edvard Munch,
Separation, 1896.
Oil on canvas.
Munch-museet, Oslo

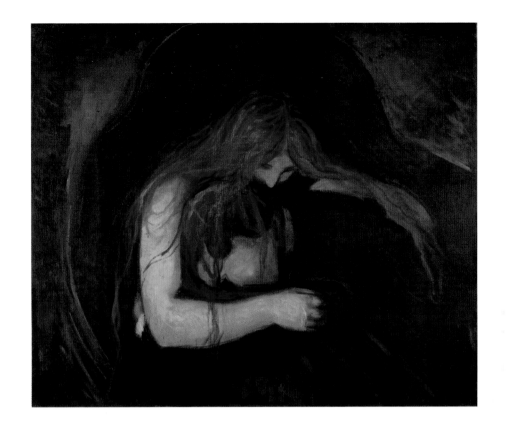

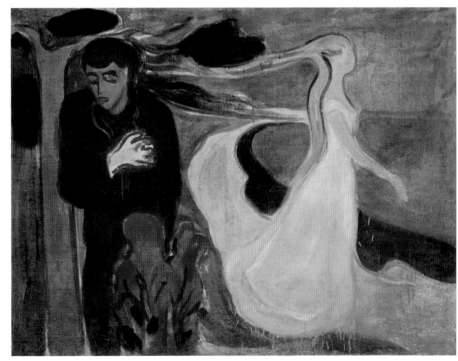

The man is leaning against a tree. His head is bent down and his eyes are closed. He is dressed in black. He is holding his chest with a red, deformed hand, as though his heart is bleeding. His left hand is obscured by a red shape.

The picture is full of contrasts, between the man in black and the woman in white, and between the different backgrounds (red and green behind the man, yellow and purple behind the woman). But there is still something that connects the man and the woman, namely the woman's hair, which trails off all the way to the man. That her hair seems to penetrate the man's heart suggests that she still means a lot to him, and that they still feel connected to each other:

But even when she has disappeared over the sea, he senses that a few strands remain in his heart. His heart bleeds, aching like a wound that never heals.
Edvard Munch

Madonna

Madonna was also called *Loving Woman*. Like *Separation*, it belongs to the love paintings of *The Frieze of Life*.

Edvard Munch, *Madonna*, 1894. Oil on canvas. Munch-museet, Oslo

We see a naked woman with long, black hair that flows over her shoulders; her eyes are closed, and she is surrounded by curvy lines. Her arms gradually become one with these lines, as though she is floating. Her head is encircled in red – the title *Madonna* refers to the Virgin Mary, the mother of Jesus, and this red shape calls to mind a halo, underscoring the religious theme. On the other hand, the woman is naked, and that makes it hard to view her as the Virgin Mary. She has a sensuous, erotic appearance. Perhaps it is first and foremost the woman's beauty that fascinates both Munch and us.

Why Did Munch Create Several Versions of His Paintings?

Edvard Munch developed *The Frieze of Life* in the 1890s, but throughout his entire career he continuously returned to the same images and created new versions, whether paintings or prints. The variant versions are not direct copies, but have been made using different colours, techniques, and sizes, and all of them are originals.

Munch made no less than eight versions of the *Vampire* and six of *The Sick Child*. By continuously repeating his pictures, Munch turned them into trademarks or signatures of a sort, thereby linking them to his identity as an artist. Munch never finished his work on *The Frieze of Life*, and indeed it became a life-time project, as its name suggested.

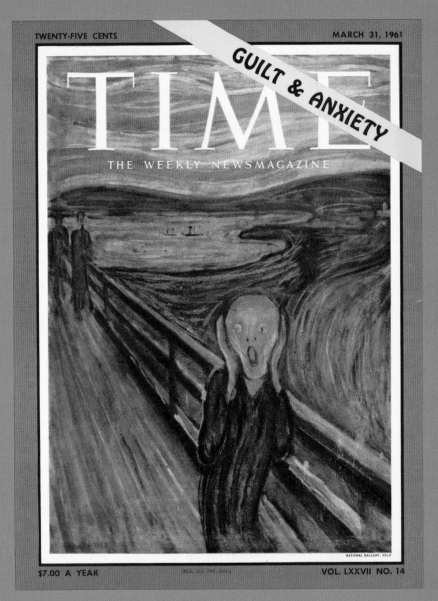

The front page of *Time Magazine*, 1961.

Lasse Jacobsen

How Edvard Munch Became Famous

Edvard Munch became famous during his own lifetime, not least because the newspapers almost always wrote negative things when he showed his new paintings.

Once in Berlin an exhibition was shut down after a few days because Munch's paintings were so different than the artworks the Germans were used to. Munch immediately sent the paintings around Germany on a travelling exhibition to other galleries that dared to show them. Many people visited the exhibitions, for they had become curious about what type of pictures Munch painted! Some of the visitors were enthusiastic about the paintings, while others were outraged and thought the art was ugly and poorly done, and violent discussions would often break out at the exhibitions. Munch enjoyed all the attention, and he joyously wrote home to his aunt from Berlin:

My pictures are now in Düsseldorf, and I hope to make some money there – I really have enjoyed this whole ruckus. I couldn't have asked for better pub-

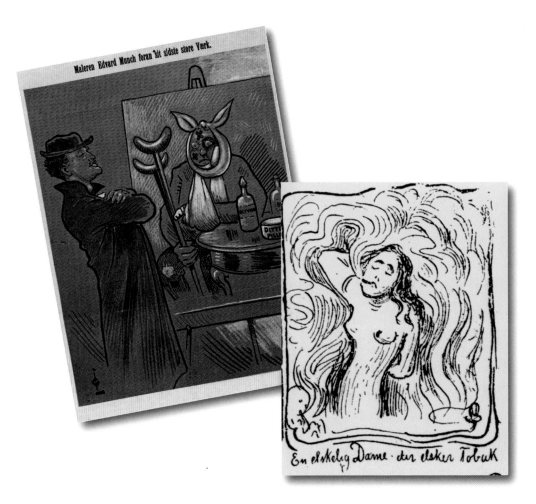

Maleren Edvard Munch foran sit sidste store Værk.

En elskelig Dame der elsker Tobak

The Painter Edvard
Munch in Front of His
Last Masterpiece,
caricature in the satirical
magazine The Viking,
1902
© Picture collection,
Nasjonalbiblioteket, Oslo

Madonna Smoking, detail
from a caricature in the
satirical magazine
The Viking, 1895
© Picture collection,
Nasjonalbiblioteket, Oslo

licity − I've nevertheless made one major mistake − namely that I didn't exhibit my paintings somewhere else here in Berlin right after the exhibition was shut down. Then I would have earned many thousands of kroner − People came from a long way away to see the exhibition. − I can't recall ever having this much fun before − It's incredible that something as innocent as painting can lead to such a fuss!

And in another letter to a friend he later boasted, *My fame forges ahead like a snowplough.*

In Munch's time there were no TVs, computers, or web sites, and it wasn't until Munch was well into adulthood that radio came into being. At the time, newspapers were rather thin, with tiny headings and almost no photographs. In addition, several weekly magazines were published in Norway. Many of these magazines were called comic magazines and were highly popular, for it was there that people could read about celebrities, such as politicians, wealthy socialites, explorers, actors, and artists. The magazines were full of jokes, songs, and amusing stories, and contained many wonderful cartoons and caricatures, that is, drawings of people whose appearance and bodies have been exaggerated in order to seem comical and laughable. Many famous Norwegians were drawn in such a way, and Edvard Munch was often portrayed as a long, thin, and lanky guy, with an exaggerated chin and a hat aslant on his head. The comic magazines helped Munch become a well-known figure.

The normal newspapers, such as *Aftenposten* and *VG*, often wrote about Edvard Munch's exhibitions and pictures. *Aftenposten* usually did not like Munch's pictures at all, and thought they were slapdash nonsense. The comic magazines jumped on the bandwagon and created wicked caricatures of Munch's paintings. After a major exhibition in Kristiania in 1895, the comic magazine *Vikingen*

printed drawings of some of Munch's pictures at the exhibition: a Madonna who smokes, and a wavery *Scream* you couldn't make heads or tails of!

It was often less-known artists who drew for the comic magazines in order to earn some money. They were probably a bit jealous of Edvard Munch, who had gradually become rich and famous, and so he was often made fun of. On one June evening in 1904, Munch wanted to paint typical scenes from a park, so with his painting utensils and easel he set up shop in the middle of the Studenterlunden park in central Kristiania. Two young couples who were relaxing in the park did not at all appreciate the attention:

Suddenly, one of the couples could no longer take it. The young woman got up and strode over to Munch. "What on earth are you up to?" she shouted at him. "Why are you sitting there staring at people you don't even know?" Munch started in surprise and shouted back at her. "Hush, miss. Sit down and don't fidget! I'm working. Don't you know who I am? I am Munch, the famous painter!"

At the same time, four boys who had been to the fairground were hanging about in front of the National Theatre. They were talking loudly and laughing. They suddenly caught a glimpse of Munch, who was sitting a bit in the distance with his easel and canvas. "Come on, lads," said the one boy, "let's take a look at that geezer over there."

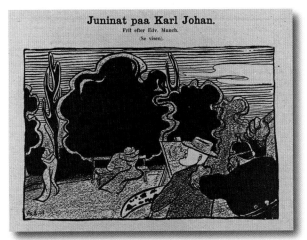

A Night in June on Karl Johan Street,
caricature in the satirical magazine *Tyrihans*, 1904
© Picture collection, Nasjonalbiblioteket, Oslo

Edvard Munch, *Bright Night in Kristiania*,
1910. Litograph. Munch-museet, Oslo

"Monk who?" continued the young woman. "A painter, huh? So that's what you're doing. Show-off!" "I'm only trying for once to paint what I see," Munch sighed. "It's such a beautiful summer night." "Yes, it certainly was beautiful before you turned up," the woman replied. "My boyfriend is allergic to being painted. It makes him ill."

The boys from in front of the National Theatre came running. They laughed out loud and pointed at the painting resting on the easel. "I am Munch, the painter, and this is art!" Munch shouted at them in irritation. "Monk, Monk, go back to your monastery!" they teased while dancing around the picture. One of

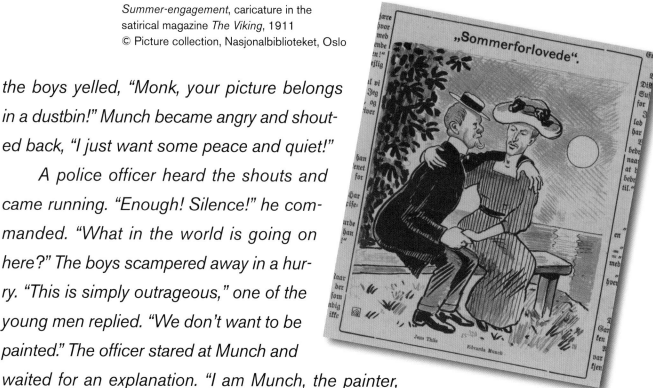

„Sommerforlovede".

Jens Thiis

Edvarda Munch

the boys yelled, "Monk, your picture belongs in a dustbin!" Munch became angry and shouted back, "I just want some peace and quiet!"

A police officer heard the shouts and came running. "Enough! Silence!" he commanded. "What in the world is going on here?" The boys scampered away in a hurry. "This is simply outrageous," one of the young men replied. "We don't want to be painted." The officer stared at Munch and waited for an explanation. "I am Munch, the painter, and I'm trying to get some work done," Munch growled. "I have read about you," the officer said. "You're a real troublemaker. I'll have to ask you to come with me to the police station and explain all of this."

The officer looked severely at the two couples. "Time to go home and sleep now!"

Though the police wanted to give Munch a fine for creating a public disturbance, he was allowed to leave the station after a short while. And then he returned straight away to the park and finished the picture! All the papers wrote about the incident the next day, and the comic magazines were full of comical songs

and drawings. Munch took some pride in those drawings, and later on he drew his own caricature of the same event.

A few years later Munch competed for the job of decorating the new University Aula, or festival hall. Funny caricatures of Munch and his proposals kept turning up in the comic magazines, and many people considered Munch's pictures to be too simple and not grand enough for the magnificent aula. One of the judges of the competition was Jens Thiis, the director of the Nasjonalgalleriet (National Gallery). He supported Munch in the competition, and that caused a great deal of controversy and debate in the newspapers. The cartoonist in *Vikingen* probably thought that Munch had too much of an inside track by knowing Thiis, and that the two of them spoke with each other too often. He has drawn them as a pair of sweethearts on a bench: Munch, who has been given the girl's name Edvarda, is wearing a dress and a ladies hat, while Thiis listens in raptures to what Edvarda is saying!

In 1914 Norwegians celebrated that it was a hundred years since the signing of the Constitution. *Dagbladet* wanted to find out who the most famous person in Norway was, so they asked Argus, which was a company people could pay to send them newspaper clippings about themselves from all the Norwegian papers. The clippings were sent in an envelope in the mail, and thus the celebrities did not have to search through all the papers themselves. The name

of *Dagbladet*'s article was "A Subscription to Fame", and two of the celebrities who received the most clippings were Edvard Munch and the polar explorer Roald Amundsen.

Of course, this way of collecting data may seem antiquated to us today, as now anyone can quickly do a websearch for their name on the internet or in an online newspaper. Try typing "Edvard Munch" into your search engine and see how many hits you get!

Edvard Munch did not like to be interviewed. If a journalist asked him questions, he would answer in a curt, reserved manner, or else he would just laugh and either joke or change the subject entirely. Munch often just wanted to be left alone. He wanted to be in control, a bit like today's superstars. But that just aroused the interviewer's curiosity even more, and Munch received even more attention. When he turned sixty in 1923 and *Aftenposten* wanted to interview him, he retorted, *I've no desire to be interviewed by the Aftenposten at all. I dislike the Aftenposten*. He could hardly forget that the paper often gave such bad press to his paintings.

In 1929 a documentary film was being made about Norway, covering the country's history and culture. The newspapers reported that it included an interview with the famous Norwegian author Knut Hamsun, and this made Munch jealous: he craved the same honour, and invited the film crew to his home at Eke-

ly. The newspapers wrote that it was quite a sensation that Munch allowed himself to be filmed. The cameraman received clear instructions from Munch: "No close-ups. You must keep at least fifty metres away!" This was a silent movie, so thankfully for Munch he did not have to say anything. When the final film was shown to the public, it showed the author Knut Hamsun with close-ups of him smiling, surrounded by his wife and all his children. A happy family indeed! In contrast, at his home in Ekely, Munch was only briefly glimpsed from afar, standing at his easel by some bushes, busy painting. The stars of the Ekely episode were instead a horse that appeared in the next scene, along with Munch's dogs, which romped about between the paintings laid out in the grass!

The Scream: A Global Icon

Edvard Munch completed almost 2,000 paintings and thousands of drawings. But it is one image in particular that has become more famous than all the others. In fact, it is perhaps the most famous picture in the world and in the history of art: *The Scream*.

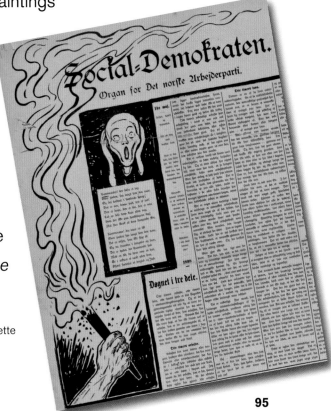

Edvard Munch and Thorolf Holmboe, vignette for the newspaper *The Social Democrat*, 1898. Munch-museet Archives, Oslo

How on earth did this happen?

Munch himself sometimes used the print version of *The Scream* as an illustration in exhibition catalogues, art magazines, and book covers. He even allowed the figure from *The Scream* to be used on its own on the front page of a newspaper called *Social-Demokraten*. The picture was already well known during his lifetime, and perhaps Munch had an inkling that it would become even more famous in the future?

It was not until after Edvard Munch's death in 1944 that the picture first became truly popular, however, as it came to be shown at exhibitions around the world. This was right after World War II, and even though life was improving around the globe, it was not easy to forget the war. People were afraid there would be more war and conflict, and many feared the new H-bomb would be used. Munch's *Scream* became a picture of this deep anxiety and fear. The imagery is simple and direct; the figure is screaming right into the face of the viewer.

The Scream became world-famous in 1961 when it appeared on the cover of the American magazine *TIME*. Usually it was only presidents, kings, sports champions, and movie stars who were featured there. *The Scream* had now become what is known as an icon, a word that comes from Greek *eikon*, meaning "picture". When some people hear the word "icon", they might think of the paintings in Orthodox churches or the small symbols you see on computer

screens and cell phones. But if you *are* an icon, that means you are a superstar and an ideal.

Andy Warhol was an American artist who was very interested in such superstars, in addition to adverts, comic books, and other ordinary, everyday items. He used these things in his art, and he called himself a **pop artist**. Warhol used stark colours and liked to repeat images in many different variants. Edvard Munch also liked to repeat his pictures in several different versions, and Warhol was probably aware of that. He created a larger copy of Munch's lithograph in several versions and in many vibrant colours. His version of *The Scream* became in a way an entirely new work of art.

Gradually *The Scream* came to be used more and more in advertising and cartoons. For example, when the Underground in London was tired of fare dodgers who didn't pay for their ticket, they hung up a poster in all the carriages. Every day on average over 2.6 million people take the Underground in London. Some people are going to work, others to school; some read a book, or send text messages from their cell phones, while others listen to music or sleep.

A boy sits fidgeting in one of the packed carriages. He's nervous because he jumped the barrier on the way in, and knows he'll be fined if he gets caught without a ticket. He stares at his reflection in the glass opposite, and then suddenly catches sight of the Scream poster overhead.

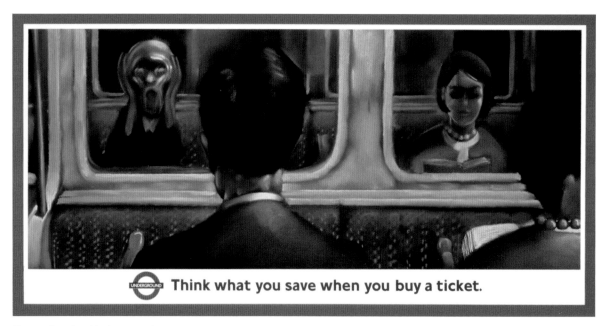

Poster, London Underground.
© TfL from the London Transport Museum collection

"I Saw the Loud Scream of Nature"

In his poem on *The Scream*, Edvard Munch wrote that he felt this loud scream in nature. And strangely enough, people have continued to *see* things that resemble *The Scream* out in nature.

The screaming may perhaps be seen in the shape of a tree or in the wavy lines of a plank of wood. In a small village in southern Italy, for example, an an-

cient olive tree calls to mind *The Scream*. The villagers are so proud of the tree that they would like to give it as a gift to the far-away Munch-museet.

A woman on the eastern seaboard of the United States, who went for a walk on the beach near her house, found a stone that she thought bore an uncanny resemblance to *The Scream*. Of course, the local paper wrote about it – it was certainly a curious piece of news! The woman hoped that a museum or an art collector would buy the stone for a handsome sum. But that is probably not that likely – Edvard Munch didn't have anything to do with the stone, did he?

More and More Famous!

The figure from *The Scream* is today the world's most famous Norwegian, more famous even than the adventurer Thor Heyerdahl, A-ha, and the former star footballer Ole Gunnar Solskjær combined. How did that happen?

The same day that all eyes were on the opening of the Winter Olympics in Lillehammer in 1994, burglars broke into the Nasjonalgalleriet in Oslo and stole one of the *Scream* paintings. As a result, the picture appeared on television news all around the globe. Ten years later the other *Scream* painting was stolen from the Munch-museet; the picture remained unfound for years despite a worldwide search for it. Once again the stolen *Scream* appeared in cartoons in newspapers

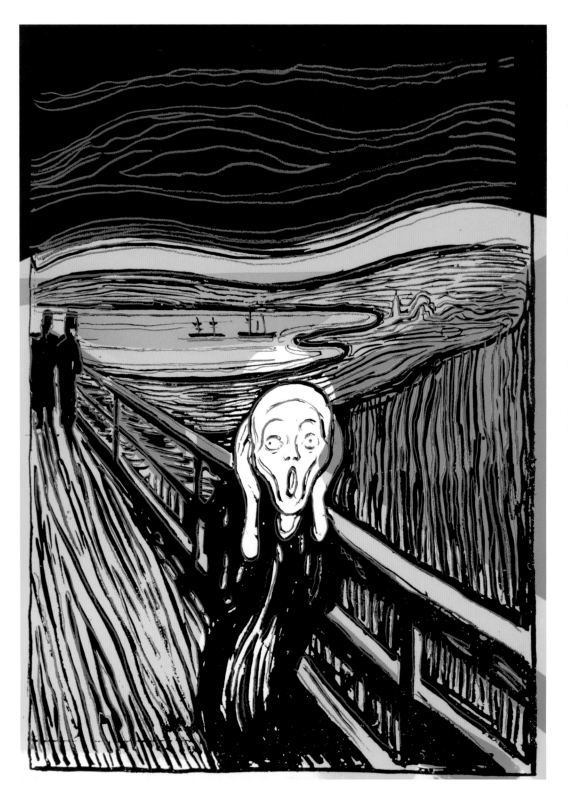

◄

Andy Warhol, *The Scream (after Munch)*, 1984. Screenprint. Haugar Vestfold Art Museum
© 2013 The Andy Warhol Foundation for the Visual Arts, Inc. / Artists Rights Society (ARS), New York

Andy Warhol, *The Scream (after Munch)*, 1984. Screenprint. Haugar Vestfold Art Museum
© 2013 The Andy Warhol Foundation for the Visual Arts, Inc. / Artists Rights Society (ARS), New York

►

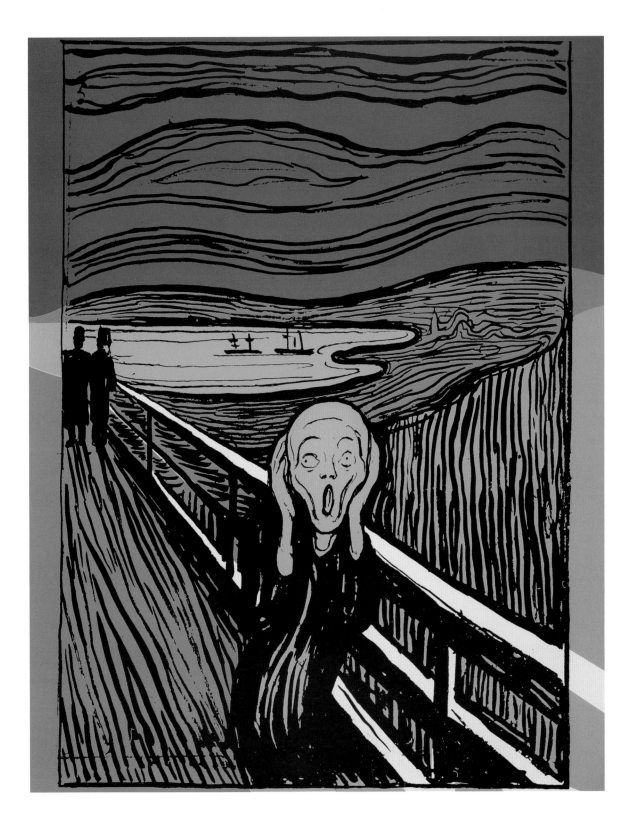

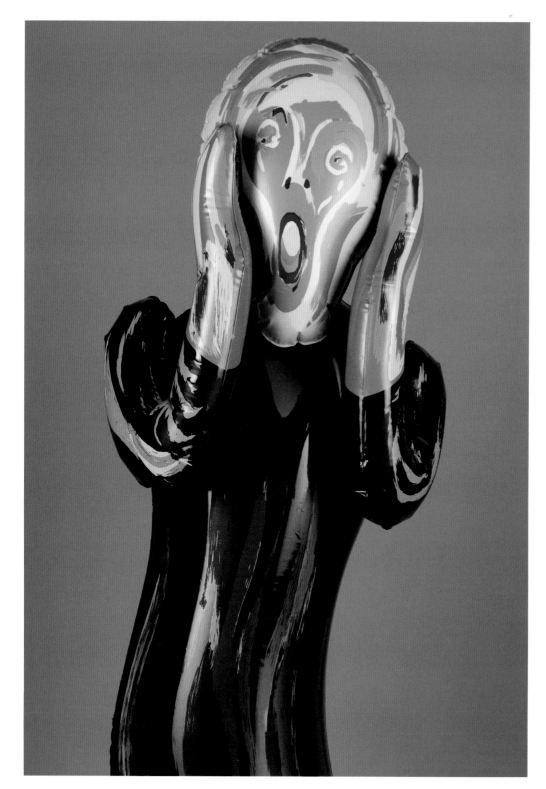

Inflatable Scream.
Photo: Munch-museet,
Oslo

and magazines everywhere. Soon you could buy *Scream* ties, cups, tea pots, and toilet paper – and even a *Scream* doll you could blow up like an inflatable beach toy.

The stolen *Scream* paintings were both finally recovered and returned to the museums, though the Munch-museet's painting had been damaged by water when the thieves hid the picture in an old bus. Munch himself once wrote that a good painting with a hole was better than a poor painting without a hole. Perhaps he thought that it wasn't such a big deal if his original paintings disappeared or were ruined – the picture would still live on in photographs, reproductions, and people's memories, thoughts, and dreams.

In 2012 a pastel version of *The Scream* was sold for the astronomical amount of 120 million dollars – more than the largest lottery win. The picture had by now become so famous that someone was willing to pay that much money for Munch's original drawing – and once again, *The Scream* featured in the news all over the world.

Had anything changed in the picture? Did the figure in *The Scream* look differently than before?

It still tried to look incredibly scared, but it was tired of standing there with its hands to its head and screaming out at nature and at everyone looking at it. It thought to itself: "I'm a superstar now. I want my own life! Many people

already look at me out there in the great big world. Far outside of this sad picture. I want the summer and the beach. I want to bask in my own fame. I want to be on Twitter and Facebook. I want my own comic strip and animated movie. Just like the Simpsons and Donald Duck. I want to go to Hollywood!"

Hey, you there, give it a rest! That's enough! Is being famous so important?

And if you answer yes, dear reader, then I would ask: Why is that so?

The *Scream* figure has become a media darling, but it belongs on the road in the flaming landscape that Munch painted. It is first there that it means something and becomes a picture of fear and anxiety.

It is not just because he is famous that Edvard Munch is important. He himself did not like people who only wanted to meet him because he was a celebrity; he mostly wanted to be alone and work on his art. The only reason Munch wanted to be famous was that more people would then become interested in his art. He wanted the paintings to be important and mean something to the people who saw them in galleries and museums. Munch wanted to show that people all over the world have the same feelings, whether you are a superstar or an ordinary person. You will fall in love, you will feel happiness, jealousy, and fear, you will lose someone you love. Munch perhaps thought that the paintings could help people deal with both the nice things in life and with the sad events that are hard to live with.

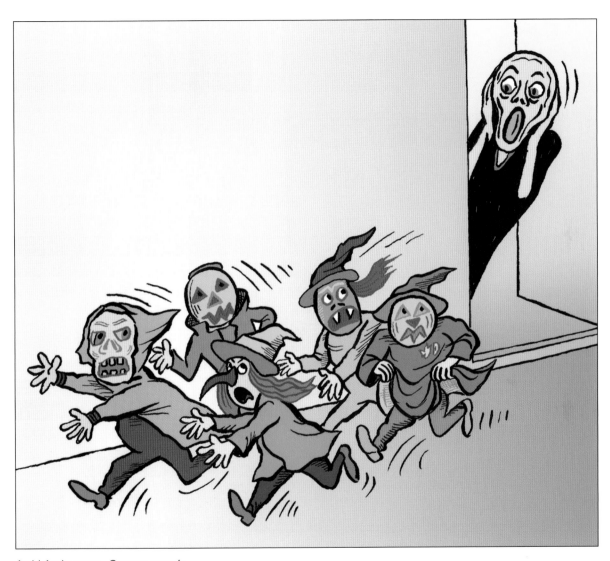

Arvid Andreassen, *Scream-parody*,
2005. © Arvid Andreassen from the
book "Scream Parodies"

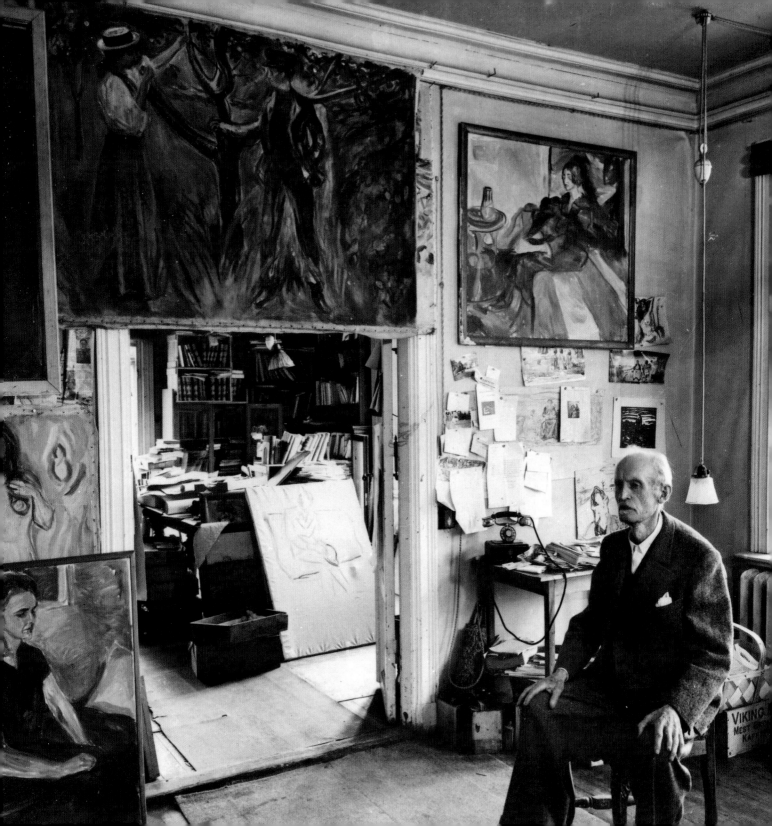

Some Useful Vocabulary

Bohemian

From the mid-nineteenth century, "bohemian" was used to refer to artists who led a free way of life, and who thereby protested against the many laws and rules that governed society.

Complementary colours

Complementary colours are colours that are "opposite" each other in the colour wheel and that emphasise each other, such as orange and blue, red and green, and yellow and purple.

Expressionism

Expressionism came into being around 1900. Edvard Munch and Vincent van Gogh are considered to be the pioneers of this style of art. As the name suggests, Expressionist paintings should not copy reality but rather *express* feelings and experiences. The colours and shapes are therefore often warped and exaggerated. The pictures also seem to be painted quickly and spontaneously, without careful planning, with vibrant colours and broad brushstrokes. In order to depict certain feelings and moods, the artist might paint red skies or green faces, as we see in several of Munch's pictures.

◄ Last photo of Edvard Munch,
Ekely 1943. Munch-museet Archives, Oslo

Fauvism

Fauvism arose in the early 1900s. The artists used the colours in an almost wild, brutal manner, and that is why they were called "fauvists", or "wild beasts". They often applied colours directly from the tube, without mixing them first. They exaggerated perspectives and simplified shapes.

Impressionism

Impressionism, as the name suggests, was about capturing *impressions*. Impressionist paintings were often painted outdoors, and Impressionists wanted to show how light and moods changed during the day and during the four seasons. They tried to capture the moment here and now, and the paintings are done with bright, lively colours and short, rapid brushstrokes.

Naturalism

Naturalists wanted to depict nature and daily life as exactly as possible. They were interested in what was actually going on in society. Naturalists wanted to shed light on and thereby change the negative sides of society.

Pastel

A pastel is a drawing done with coloured chalk on paper or canvas.

Perspective

Perspective is a term for the various effects an artist can use to create a drawing or a painting. One of these effects is size, where the farther away something is in the picture, the smaller it is depicted. The artist can also use colours of different hues to create space and distance. In central perspective the most important part of the picture is placed in the centre, while the other figures and objects are linked to the centre through invisible lines.

Pop Art

Pop Art is a type of art that is based on realistic figures and shapes, but done in a style that is inspired by comic strips, movies, an ads. Pop Art was the dominating art movement of in the United States in the 1940s and 1950s.

Primary colours

Red, yellow, and blue are the three primary colours. The secondary colours (orange, green, and violet) are created by mixing the primary colours in different combinations. By combining yellow and blue, for example, you get green.

Realism

In Realism, artists wanted to depict nature and culture as they actually were, and painters began to paint outdoors in earnest. Realism was a reaction against the unrealistic, dressed-up representations of Romantic painting.

Studio

A studio is a type of workshop or work space where one or more artists work.

Symbolism

Symbolism as a movement in art that was opposed to naturalism. Symbolists tried to appeal to people's feelings, dreams, and intuitions, rather than to reason. Their goal was to express what was hidden in the world around us and what was concealed in the mind of mankind. They aimed to bring this to light through symbols, that is, concrete objects that gain a different meaning than they normally have. The paintings that Munch made in the 1890s are often called symbolic.

Watercolours

Watercolours, also known as aquarelles, are pictures that are painted with water-soluble colours.

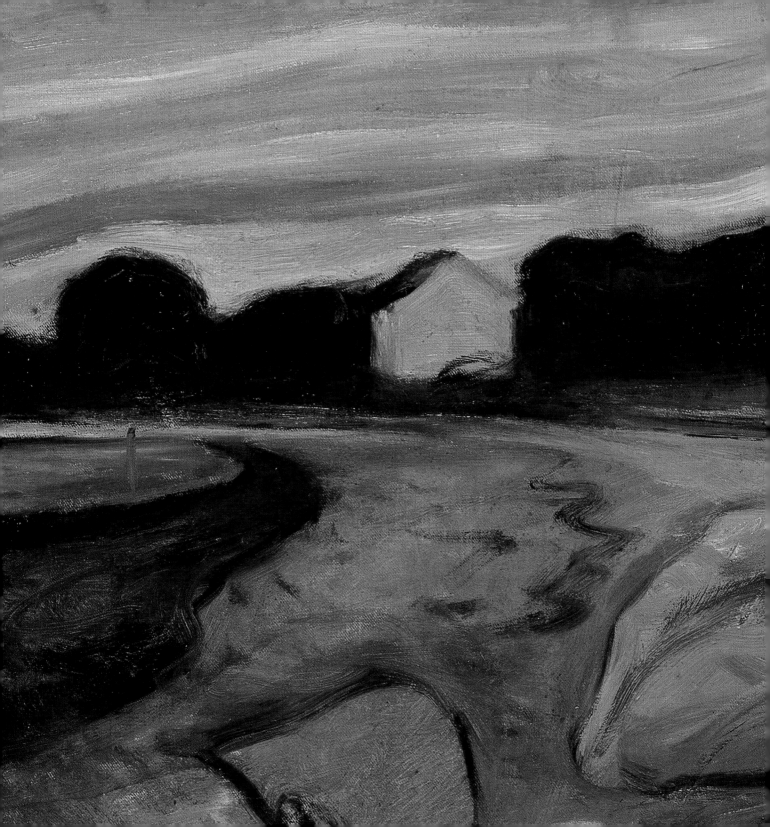